IMAGES
of America
WOMEN *in*
LEXINGTON

IMAGES
of America

WOMEN *in*
LEXINGTON

Deirdre A. Scaggs

ARCADIA
PUBLISHING

Published by Arcadia Publishing
Charleston, South Carolina

Printed in the United States of America

Library of Congress Catalog Card Number: 2005935861

For all general information contact Arcadia Publishing at:
Telephone 843-853-2070
Fax 843-853-0044
E-mail sales@arcadiapublishing.com
For customer service and orders:
Toll-Free 1-888-313-2665

Visit us on the Internet at www.arcadiapublishing.com

This book is dedicated to Dorothy Lee Wilson and Alice Chiara Scaggs.

CONTENTS

INTRODUCTION

Lexington is the second-largest city in Kentucky, located centrally in the state in what is known as the Bluegrass Region. It is noted for a once-major burley tobacco market and for the breeding and selling of horses. In 1775, the town was named after Lexington, Massachusetts, where the Minute Men first encountered the British regulars on the village green during the American Revolution; permanent settlement began in 1779. Between 1790 and 1800, the town quickly became an area with fine homes, estates, and diverse manufacturing. Much has been written about the history of Lexington, the tobacco and horseracing industries, and notable figures, but the discourse and scholarship on the role women have played in Kentucky's history has not been adequately covered. The status of women in Lexington greatly changed after the Civil War. Many women were key figures in altering the traditional, male-dominated society. In 1888, the Fayette County Equal Rights Association was founded. Notable women such as Madeline McDowell Breckinridge, Sophonisba Breckinridge, and Laura Clay made great strides for women in the late 19th and early 20th centuries.

Kentucky's repositories are rich sources of primary-source material documenting the state's history and preserving evidence of the role that women have played in this history. The images in this book come from several collections in the Archives of University of Kentucky's Libraries. The bulk of the images come from the John C. Wyatt *Lexington Herald-Leader* Photograph Collection, 1939–1990. The origins of the *Lexington Herald-Leader* can be traced back over 130 years to the *Lexington Daily Press*. Its descendant, the *Morning Herald*, was first published January 1, 1895, and became known as the *Lexington Herald* in 1905. Another newspaper with a large circulation during this time was the *Kentucky Leader* (formed by a group of Fayette County Republicans in 1888), which eventually became known as the *Lexington Leader* in 1901. In 1937, the owner of the *Leader*, John G. Stoll, bought the *Herald*, and both daily papers were published concurrently, the *Herald* in the morning and the *Leader* in the afternoon, for the next 46 years. The newspapers had a combined Sunday edition, but their editorial policies remained quite different. The *Leader* was a Republican, society-based evening edition, and the *Herald* a more political, heavily Democratic morning edition. In 1973, the newspapers were purchased by the Knight-Ridder Corporation and in 1983 were merged into a single morning paper that is still published as the *Lexington Herald-Leader*. The coverage of the newspaper has grown over the years, and while its focus has always been on the Lexington metropolitan area, including seven additional counties, it presently circulates in 78 of Kentucky's 120 counties.

The photograph collection of the *Lexington Herald-Leader* (LHL) consists of an estimated 1.5 million unique photographic negatives spanning the years 1939 to 1990. The collection also contains associated newspaper clippings, job sheets, and hand-written photographers' notes. The *LHL* collection is an unparalleled source of photographic evidence of the many historical, cultural, and industrial changes that have shaped Lexington and its surrounding region. The scope of the collection highlights the day-to-day activities of Kentuckians. It follows the changing urban landscape of Lexington, the agricultural, tobacco, and horseracing industries,

key national events such as World War II and Vietnam, and notable regional and national figures. Importantly, it is the only large, comprehensive newspaper photographic archive in Central and Eastern Kentucky and is the most extensive single collection in existence of still photographic images documenting Lexington's 20th-century history.

The author compiled these images to highlight the activities, achievements, and lives of everyday women. Their significance lies in the roles they have played in Kentucky history and the broader history of women. *Women in Lexington* began during initial stages of processing the John C. Wyatt *Lexington Herald-Leader* Collection at the University of Kentucky. The author began mentally collating images she was interested in and felt that she had a connection to. This interest grew into a presentation for the women's studies colloquium series and has culminated in this pictorial history.

The women in the author's life have been strong; they have been Kentucky women, and their lives are part of history, however minute or great their contributions were. Their day-to-day lives were typical and extraordinary and not unlike the lives of other Kentucky women. Their collective experiences create the larger historical narrative and memory. This history is created by everyone, not just the wealthy and well known.

Historically, Kentucky women have been crucial forces and contributed to a diverse range of fields. They have contributed to the women's suffrage movement, the education system, charitable organizations, architecture, medicine, law, and key women's groups. The following images are not a comprehensive study of this contribution and history, but are meant to highlight a group of images to provide a glimpse into the roles of Lexington women over time. It should be noted that at the time these images were created and identified, it was common practice for women to be described by their husbands' names. It is the author's regret that she could not identify the women appropriately.

One

WAR INVOLVEMENT

From 1940 to 1945, more than 6 million women were urged to enter the workforce, and women of Lexington were no exception. The popular figure Rosie the Riveter was part of a government campaign to bring women into the workplace during the war. World War II allowed women to take over traditional male responsibilities and became an outlet for women to work outside of their homes. Lexington women not only worked in factories and in the tobacco industry but also enlisted, and they were actively engaged in home campaigns. During World War II, more than 150,000 women served in the Women's Army Corps in non-combat positions. Even though the American public was initially resistant to this, it was promoted by the idea that each woman who served would release a man for combat. Lexington women enlisted in various branches of the military, tested bombers, entertained the troops, and trained pilots. After the war, when the men came back, many women were forced to give up their jobs and return home. Women had to face the difficult choice of working for low pay or staying at home because the wages were not enough to cover the cost of child care.

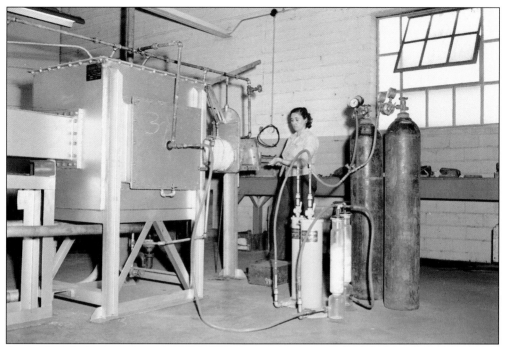

An unidentified woman operates a piece of equipment at the Archer and Smith tool company. The company opened a new metallurgical laboratory in July 1945. (2004AV001 1.13-18.03.)

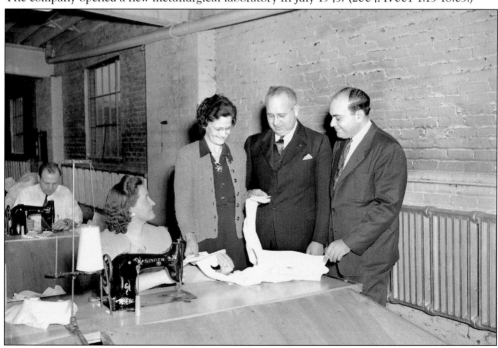

C. W. Sulier (center) was a former president of the Lexington Chamber of Commerce; Matthew Barrett (right) was resident manager for Cluett, Peabody, and Company; they stand with two unidentified female employees at work in Cluett, Peabody, and Company, located at 509 West Main Street. This picture was taken in February 1944. (2004AV001 1.13-315.02.)

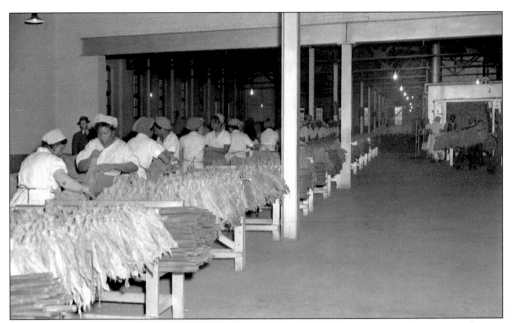

A group of women work in the hanging room of an unidentified Lexington tobacco warehouse. Anywhere from 25 to 150 women would take the tobacco from baskets and hang it on sticks to prepare it for the redrying process. African American women worked in the tobacco industry under extremely poor conditions; the warehouses were often poorly lit and had little ventilation. (2004AV001 1.13-567.10.)

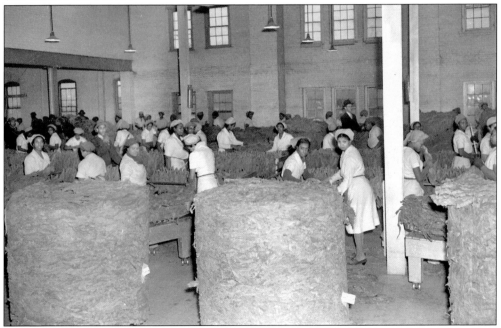

A group of women work in an unidentified Lexington tobacco warehouse. Often African American women in the tobacco industry could expect to earn as little as $6.50 a week. In the warehouses, women were perpetually sweeping up scraps of tobacco and taking them to other women to pick out the best of the scraps and throw out the dirty or ragged leaves. (2004AV001 1.13-567.11.)

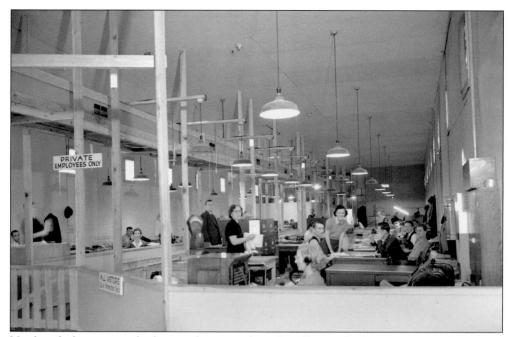

Unidentified women and other employees work in the office at the Lexington Signal Depot in Avon, Kentucky. The depot was under construction during early years of World War II (exact dates of construction are unknown). (2004AV001 1.13-318.15.)

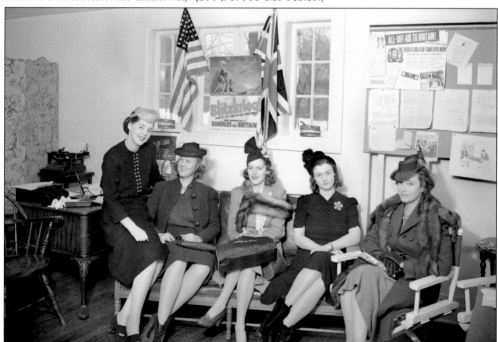

These unidentified women were involved with Bundles for Britain. Initially begun as a knitting circle that provided knit garments for British sailors, Bundles for Britain spread through the United States in the 1940s. They provided food, clothing, and supplies to those affected by the war. This picture was taken at 159 Bar Street in February 1941. (96PA101 4675a.)

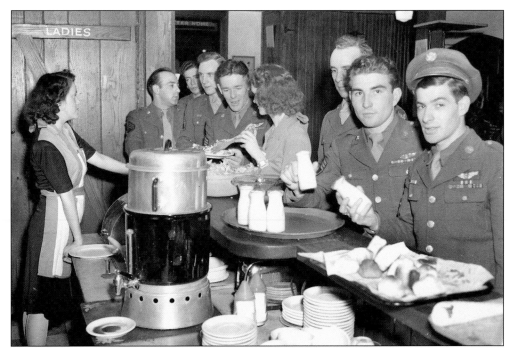

Unidentified women serve food to a group of servicemen at the Lexington Stopover Station in 1943. (2004AV001 1.13-535.05.)

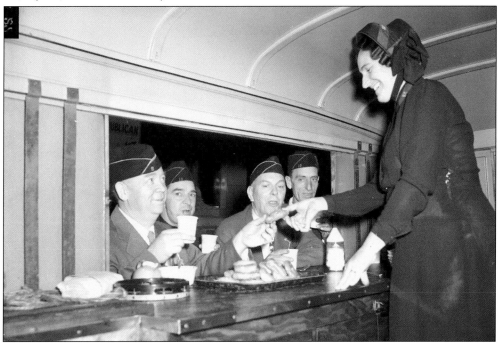

Dorothy Case serves doughnuts and coffee at the mobile canteen of the Salvation Army to a group of legionnaires in Lexington for the state convention. The legionnaires, pictured from left to right, are John Handy, John J. Howard, Jack Bingham, and Miller Blanton. This picture was taken in September 1945. (2004AV001 1.13-22.)

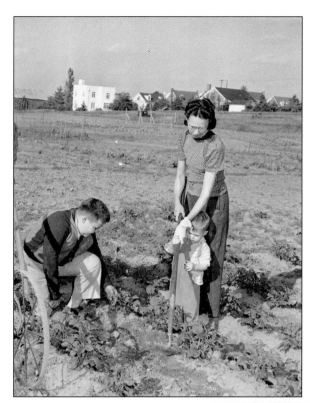

Mrs. E. H. Hornsby works her plot in the Montclair Victory Garden project in May 1945. Many Lexingtonians used their backyards to help ensure an adequate food supply for civilians and troops. (2004AV001 1.13-334.01.)

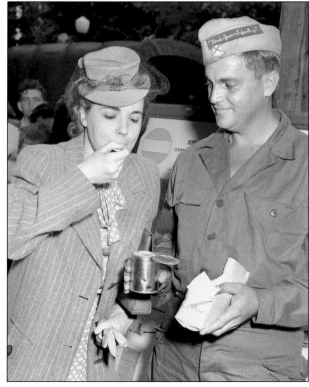

At *Here's Your Infantry*, Margaret Maxwell samples military rations as Pfc. Cecil W. Bailey of Sardis, Mississippi, looks on. The army show *Here's Your Infantry* was put on by an army group in the interest of the Seventh War Loan Campaign in May 1945. (2004AV001 1.13-23.03.)

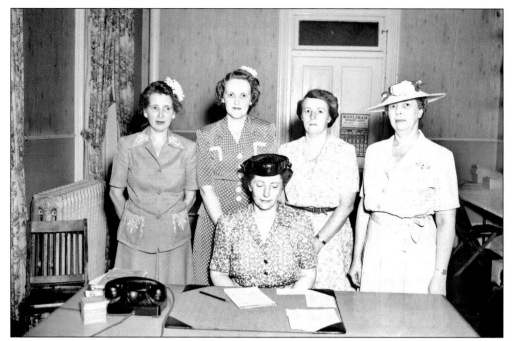

These women were captains of residential teams that met their quotas in the Fifth War Loan drive in July 1944. Pictured from left to right are (standing) Mrs. E. W. Essig, Mrs. R. T. Vermont, Mrs. Efflo King, and Mrs. Earl Rose; (seated) Mrs. Robert M. Rodes, division leader. (2004AV001 1.13-373.)

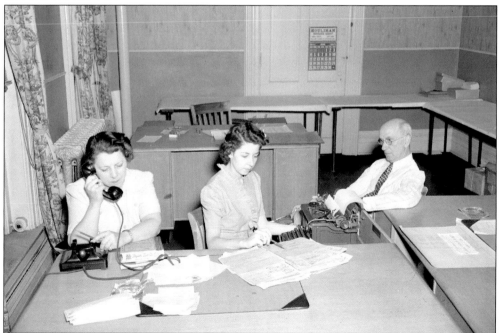

These employees of the Fifth War Loan Office are, from left to right, Daisy Walker and Mrs. Wallace K. Reese, both full-time employees, and James J. Morris, a full-time volunteer director. This picture was taken in June 1944. (2004AV001 1.13-367.)

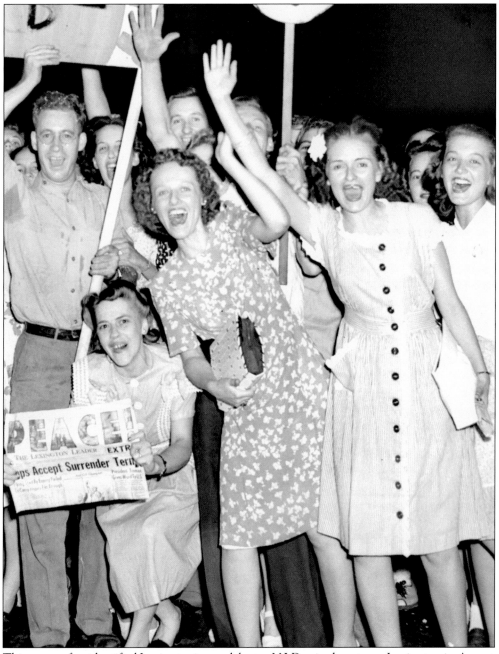

This group of unidentified Lexingtonians celebrates V-J Day in downtown Lexington in August 1945. (2004AV001 1.13-268.01.)

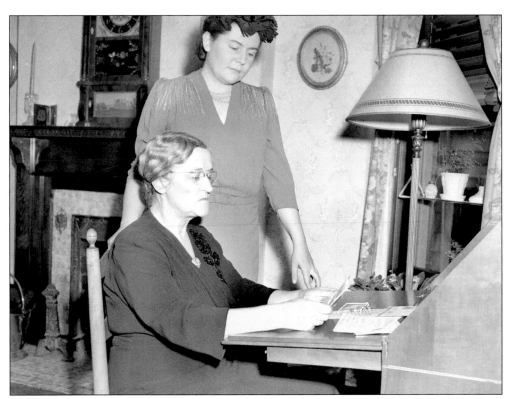

These two women sold war bonds house to house in December 1944. Pictured are Mrs. L. J. Boyers, seated, and Mrs. George H. Patrick. (2004AV001 1.13-412.)

These three war mothers were members of the "Baby Buggy Brigade." They solicited bond sales in their home neighborhood while giving their children afternoon outings in May 1945. The women are, from left to right, Mrs. William R. Nash, Mrs. Zeola Tabor (buying a bond), Mrs. J. P. Rose, and Mrs. Robert N. Price. (2004AV001 1.13-42.)

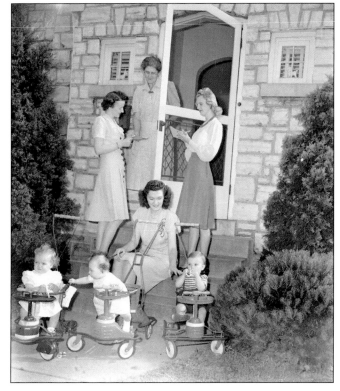

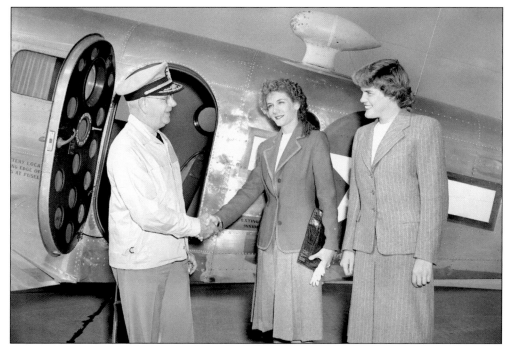

Rear Adm. Arthur S. Carpender greets the adjutant general and another woman who enlisted in WAVES at Bluegrass Field in September 1944. WAVES was established in 1942 as Women Accepted for Voluntary Emergency Services. (2004AV001 1.13-52.)

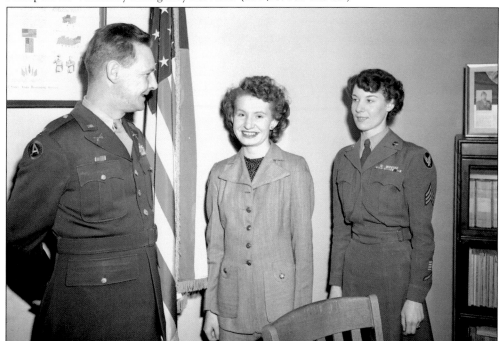

From left to right, Capt. Winfield Scott Chadwick; Elizabeth Ann Combs, Lexington's first Women's Air Force (WAF) enlistee; and Sgt. Gertrude Hymans of the army recruiting station are pictured in 1949. (2004AV001 1.04-267.)

Mrs. W. R. Engle was a member of WASP (Women Air Force Service Pilots), who were the first women in history to fly American military aircraft. This picture was taken in September 1965. (2004AV001 W.2240a.)

Mrs. John Doucomes served in the WAVES. This picture was taken in September 1965. (2004AV001 W.2240b.)

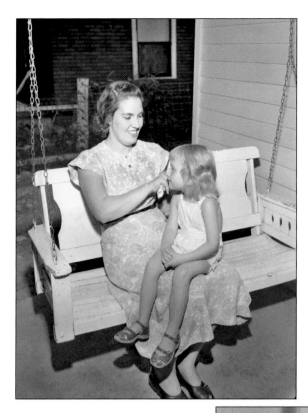

Lucille Judy and her daughter, Diana, are pictured on a porch swing in July 1949. Judy was an employee of General Electric but was laid off when women were no longer necessary at the plant for postwar production work. She decided not to go back to work because the cost of child care was more than she would earn elsewhere. (2004AV001 1.04-1043.04.)

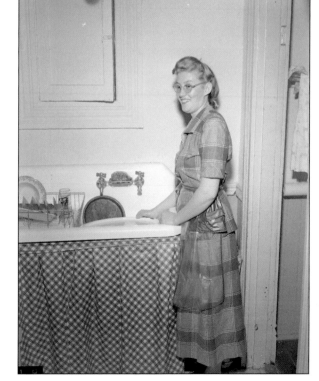

Dorothy Dudderar washes dishes at her home in July 1949. After Dudderar was laid off from General Electric, she accepted a job as a bakery worker. At the bakery, she worked 48 hours a week for 50¢ an hour, longer hours for less than half the pay. (2004AV001 1.04-1043.02.)

Two

WOMEN AT WORK

In 1911, the Consumers League of Louisville asked the governor to appoint a commission to investigate the conditions of working women. The tobacco industry was a major employer of women, and it paid poorly; the women worked long hours, and the warehouses lacked ventilation. The clothing industry offered seasonal work where wages were paid by the piece. The mills were extremely hot and loud, in addition to other limiting factors. By World War I, wages increased but so had prices, and the long hours and occupational hazards persisted. By 1937, more women were working, but conditions did not improve for African American women until civil rights legislation. After World War II, Lexington developed. Manufacturing expanded, enrollment at the universities grew, the population increased, and new housing crept into the farmlands. As the city grew, so did the opportunities for women in the workforce. By 1960, more women were getting jobs outside the home, and by 1969, the percent of women in the workforce was up to 43%, an increase from 25% in 1940. In 1963, congress passed the Equal Pay Act, enacting the first federal law prohibiting sexual discrimination. Many of the following representations are not surprising, as they fit the conventions dictated by the times, but some highlight the women who became the first to have jobs that previously had only been filled by men. The images document women in the nursing, entertainment, retail, and other professional fields.

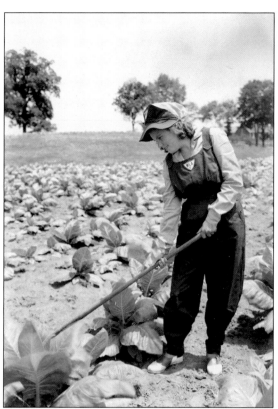

An unidentified woman tends tobacco in a Lexington field around 1940. She is wearing a hat and overalls with the Women's Land Army emblem sewn on them. The WLA was a national effort to supply laborers to U.S. farms. (1998UA001 18 4.)

These two unidentified female employees worked in the First National Bank and Trust Company. This picture was taken in March 1940. (2004AV001 1.02-274.33.)

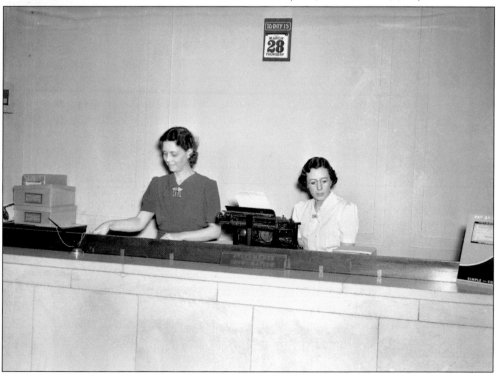

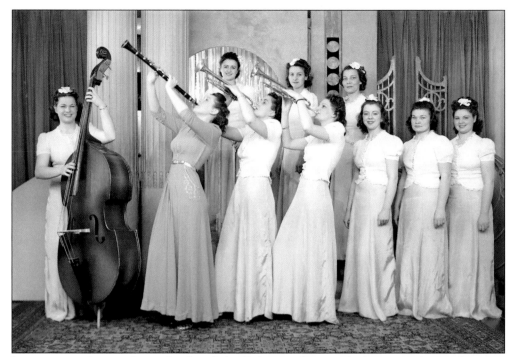

Lexington performers Betty Coed and the Debs are photographed in an unknown location. This picture was taken in December 1939. (96PA101 4383.)

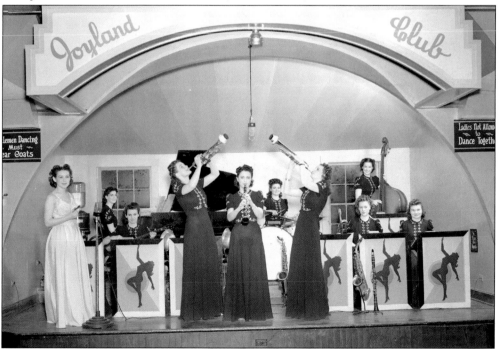

Betty Coed and the Debs are pictured performing at Joyland Club in February 1940. They often performed during the winter months when it was more difficult to draw bigger, national acts. (96PA101 4446.)

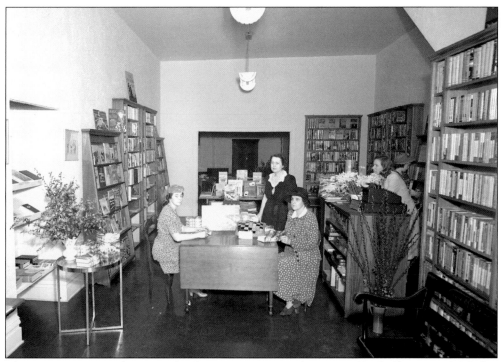

These women are working at a book-signing event in the Morris Book Shop at 110 Market Street in April 1941. (96PA101 4695a.)

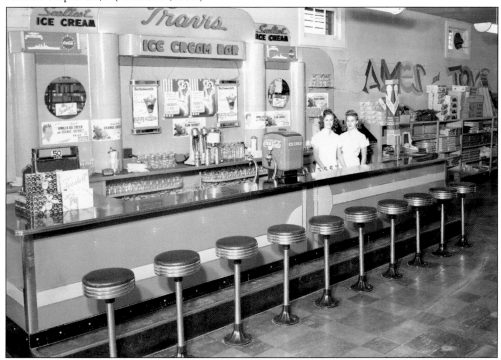

These two women were employees of the Travis Phar ice cream fountain in April 1944. (96PA101 5183b.)

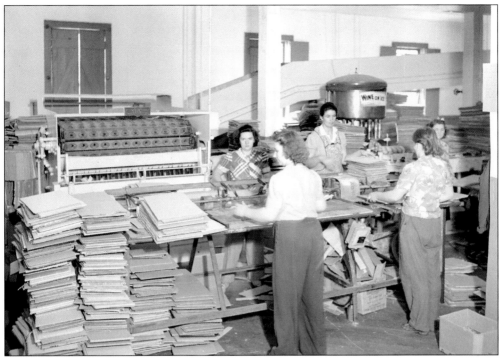

These women are working on an assembly line at the National Distillers Corporation packing department in September 1944. (96PA101 5251a.)

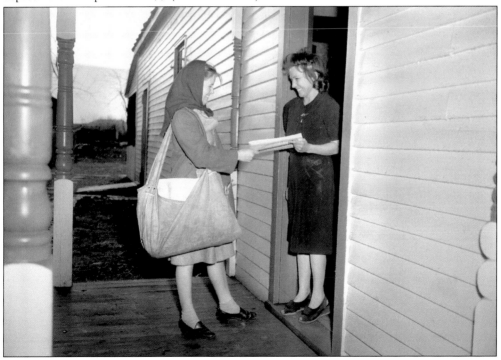

Geneva Bishop, the first female carrier for the *Leader*, delivers papers in Irishtown in 1945. Bishop attended Lexington Junior High School. (2004AV001 1.13-282.03.)

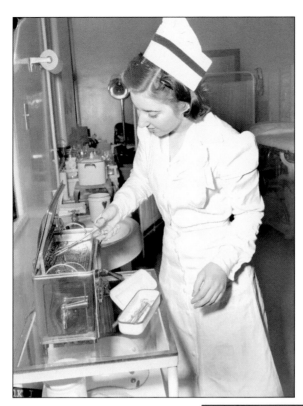

Nancy Hendricks, 20, worked in the Good Samaritan emergency room in April 1946. (2004AV001 1.13-222.)

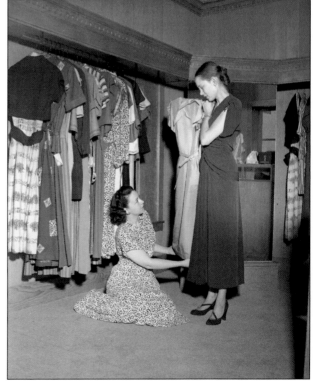

Donna Haynes (right), the proprietor of the Tall Shop at 115 East High Street, is pictured with her associate, Mrs. George Bunnell (Gene Ray Crawford), in July 1949. The Lexington specialty shop sold long dresses for tall girls. Haynes said in regards to the clothing and her own tall stature, "the current doctrine is not to try to disguise a tall girl's height, but to take advantage of it." (2004AV001 1.04-926.)

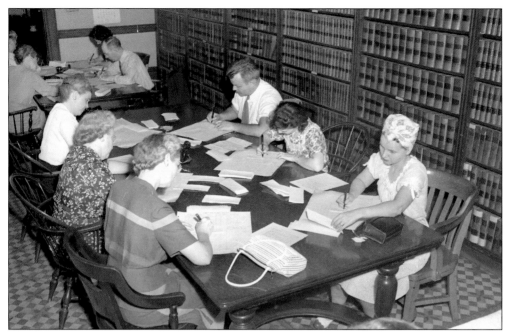

These employees of the Fayette County clerk's office are indexing records in July 1946. Pictured clockwise around the table from bottom left are Flora King, Genevieve Moran, Septa Nicholls, J. T. Welch, Mrs. J. T. Welch, and Josephine Bryant. (2004AV001 1.01-71.)

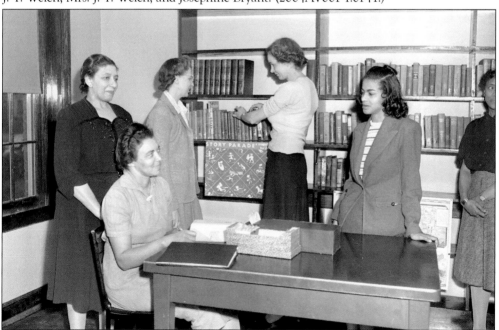

These women were involved with the opening of the Manchester Street Library branch that opened at Charles Young Community Center on East Third Street. Pictured from left to right are Mrs. H. H. Rowe, director of the African American recreation board; Harietta Jackson, seated; Mrs. Henry Hornsby, volunteer in charge of setting up the branch; Mrs. T. E. van Meter, executive secretary of Manchester Street Library; and Carolyn Johnson. (2004AV001 1.13-68.)

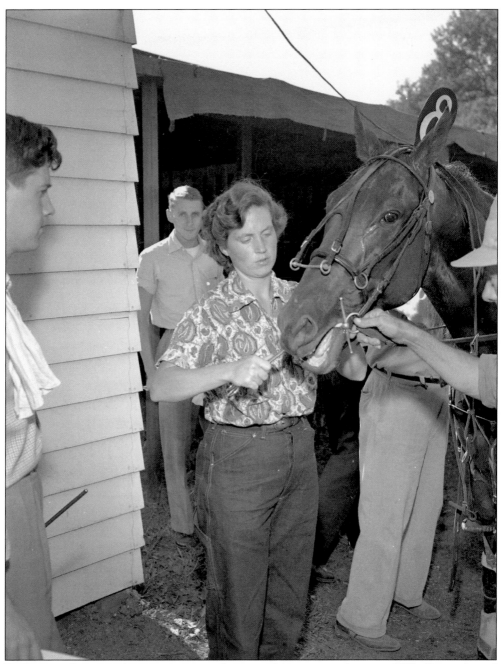

Dr. Jeanette Sams, track veterinarian, performs a saliva test on a horse in 1952. She graduated from Cornell and served as track veterinarian at Fairgrounds Speedway in Louisville for four years. Dr. Sams was the first woman to be a track veterinarian at the Lexington Trots. (2004AV001 2.01-79.03.)

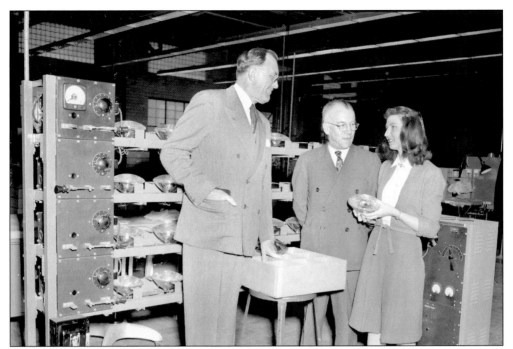

From left to right, Charles E. Wilson, president of General Electric; M. L. Sloan, company vice president; and Nevelyn Gordon, a Lexington Lamp Works plant employee, discuss one of the plant's completed sealed-beam lamps, held by Gordon, in January 1947. (2004AV001 1.02-22.)

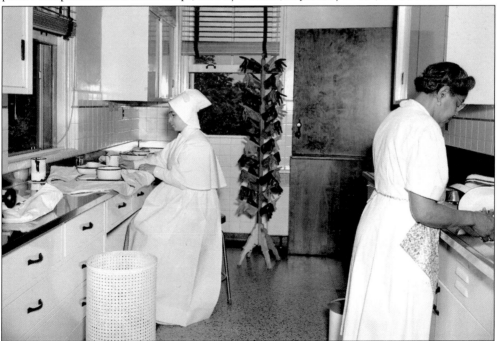

Two unidentified employees work in the sterilizing department at St. Joseph Hospital in September 1947. The new installation was authorized by the Sisters of Charity of Nazareth, who operate the hospital. (2004AV001 1.01-236.03.)

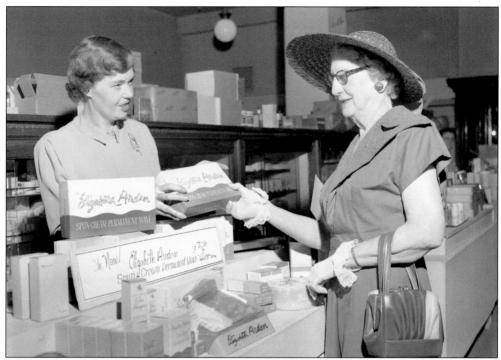

Mary Pilyer (left) hands a package to Mrs. Harold F. Johnson at Wolf-Wile's store in May 1950. (2004AV001 1.05-869.01.)

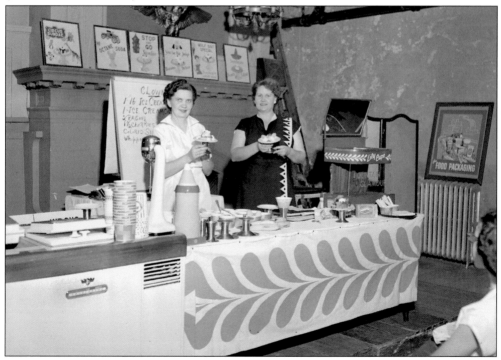

Bessie Scott (left) and Gladys Schultz of the Lily-Tulip Cup Corporation hold a demonstration on the making of ice cream sodas and sundaes in June 1952. (2004AV001 G.1460.)

Gladys Scheer (lying down) was the first blood donor when the Red Cross bloodmobile came to Lexington in February 1952. Mrs. R. E. Scofield is at center, and Mrs. Helen Cooley is the nurse. (2004AV001 G.365.)

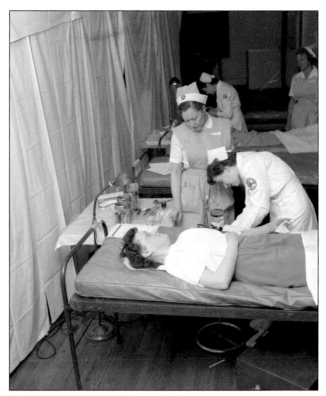

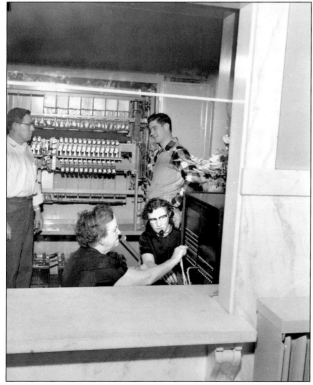

Anna B. Peak (seated left) places a call through the new telephone switchboard at city hall in January 1953. Anna, an operator at the building for 24 years, was instructed by Eula Oden (seated right), Private Branch Exchange (PBX) instructor for the General Telephone Corporation. (2004AV001 H.12.)

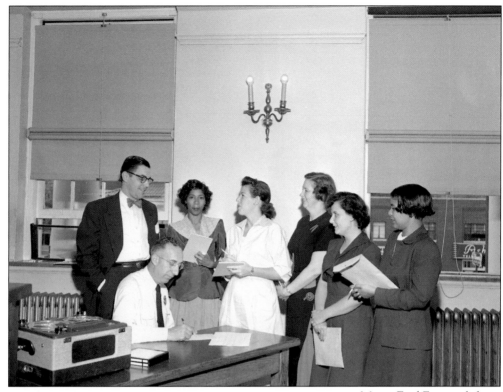

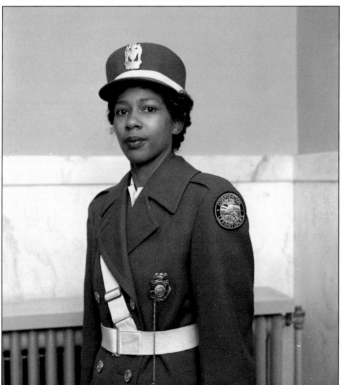

Mayor Fred Fugazzi, left, welcomes trainees of Lexington's Division of Traffic School Guards in September 1952. Sgt. Joe Modica, seated, was in charge of the school, and classes were held at Henry Clay High School. Trainees, pictured from left to right, are Josephine Hatchett, Lois Carter, Emily Hay, Louise Stivers, and Jane Hawthorn. (2004AV001 G.2049.)

Josephine Hatchett was a traffic school guard at Fifth and Limestone Streets in downtown Lexington. This picture was taken in April 1953. (2004AV001 H.1077.)

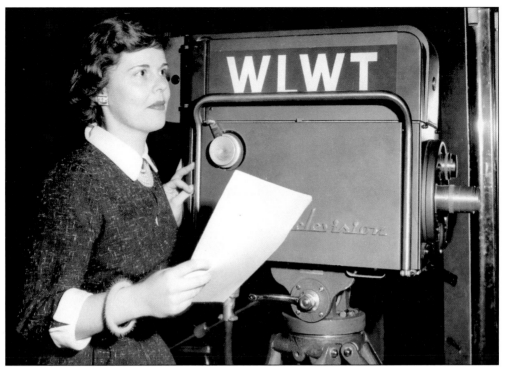

Marge Hoenig of WBKY visits WLWT in Cincinnati, Ohio, c. 1940. (79PA104 427.)

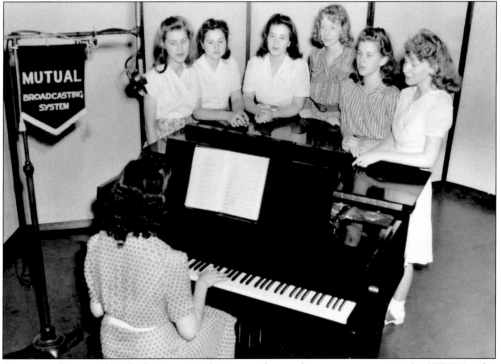

A group of six unidentified women gather around a studio piano to sing at the WBKY radio station around 1940. (PA79M104 327.)

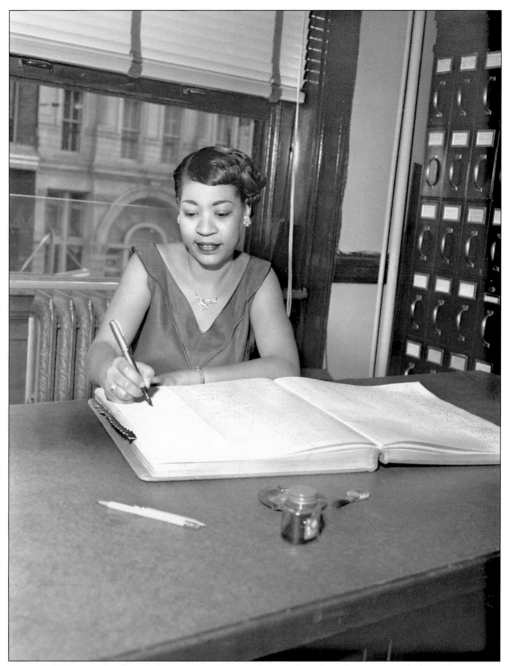

Georgia R. Bates, the first African American to be employed in the county clerk's office, works in the Chattel Mortgage office in September 1955. Georgia was a graduate of Dunbar High School and attended West Virginia State College, where she studied business administration. (2004AV001 K.2002.)

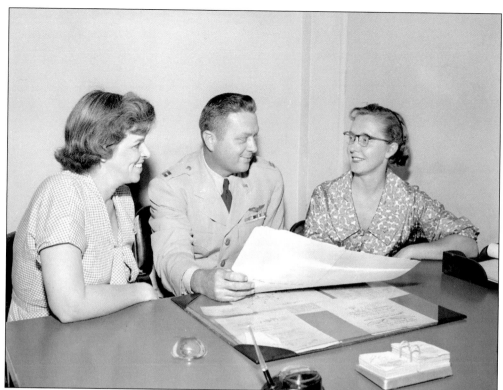

Mrs. P. C. Emrath, left, the retiring civilian supervisor at the Ground Observer Corps; Capt. Warren B. Christy, in charge of the Filter Center for the Air Force; and Mrs. Nick Wanchic, incoming civilian supervisor, are photographed at work in August 1955. The supervisor had charge of all civilian workers at the center, coordinated their efforts with the military, and kept records on nearly 6,000 civilian personnel at the center and at observation posts throughout the state. (2004AV001 K.1828.)

Ina Carrington, cashier at the Paymaster Loan Company, describes how big the muzzle of a holdup man's gun looked during the robbery that she was witness to earlier in September 1955. (2004AV001 K.2182.)

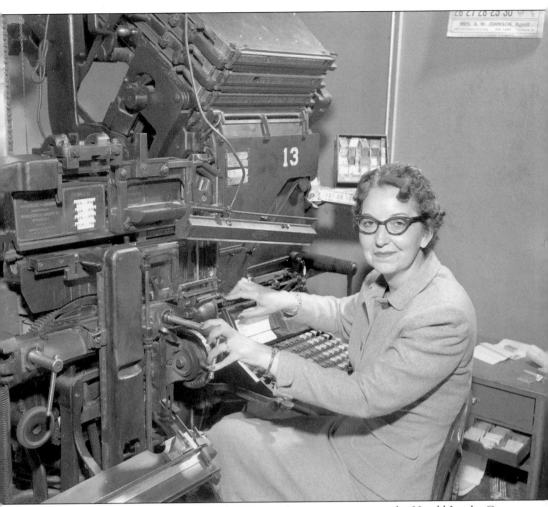

Mildred Parsons Burns became the first woman linotype operator at the *Herald-Leader* Company in April 1949. Mrs. Burns's employment in the composing room of the *Herald-Leader* put an end to the last all-male department of the newspaper. (2004AV001 Q.897.)

Lexington policewomen Ida K. Oplas (left) and Susan Garr model their new uniforms in January 1962. The blue serge uniforms were tailored to match those worn by the male members of the department and were the first uniforms to be worn by women since they first joined the force in 1917. (2004AV001 T.278.)

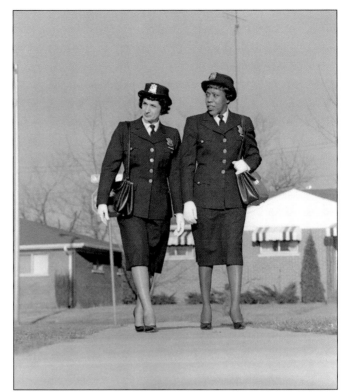

Ruby Flynn, named substitute city letter carrier for the Lexington Post Office, became the city's first peacetime woman mail carrier in January 1963. Mrs. Flynn did civilian work with the Navy Department during World War II. (2004AV001 U.2444.)

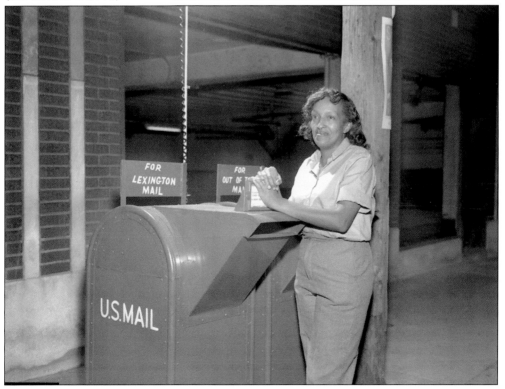

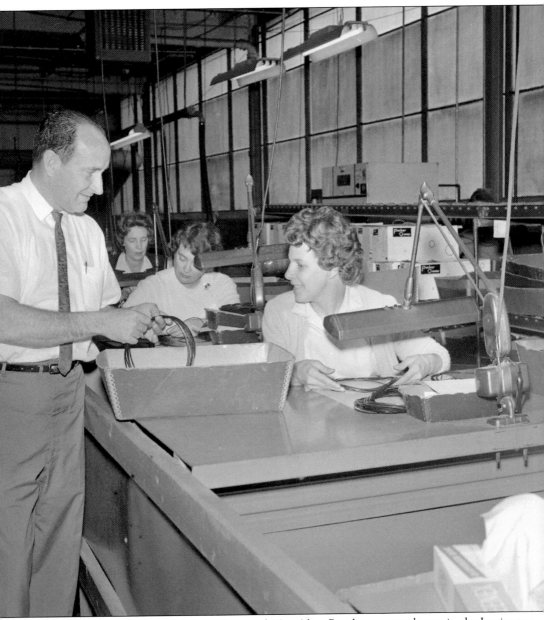

Ed Reinsch, production superintendent, and Mrs. Alice Parida were employees in the Lexington Parker Seal Company in May 1964. Parida was one of 17 employees who started when the plant opened in 1959 and one of the 11 original employees to remain with the company. The Lexington Parker Seal Company made O-rings that were used in hydraulic and pneumatic systems. (2004AV001 V.1191.)

Suzanne E. Hudson works in the Lexington Post Office in September 1966. Hudson became the first female window clerk to work at the Lexington Post Office since 1952. She was among 27 women employees, including two carriers, several clerks, stenographers, and secretaries. In 1960, there were only six women with the post office. (2004AV001 X.2137.)

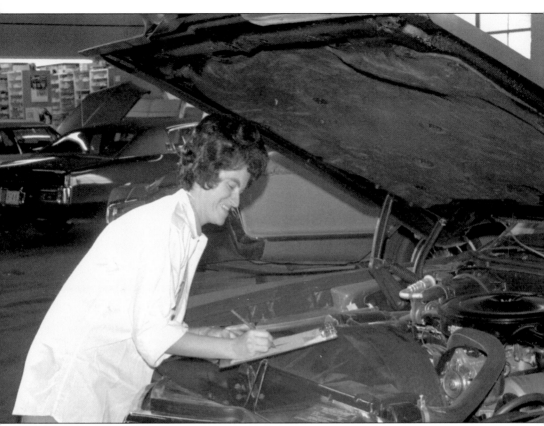

In 1968, Nelye Strong became Kentucky's first female automobile inspector, breaking into a male-dominated field. She is pictured at work in the Charlie Sturgill Motor Company and was an experienced mechanic who at one point owned an interest in a garage. (2004AV001 Z.1963.)

Three

THE EXCEPTIONAL

The following women were outstanding in various ways. A great many of them were the first to achieve status in male-dominated fields, some of them have both ordinary and extraordinary achievements, and a few were notorious in Lexington. The majority of these women are not unlike many we may all know. They are our neighbors, our sisters, women we pass on the street, and our friends. These are the women that have each created their own history in this city; some left more well-known marks, but however significant they may have been, those achievements have been recorded in these images. The photographs included in this chapter were not chosen by the status of the women's achievement, and some may be considered ordinary. They range from accomplishments in education and non-conforming professions to unusual pastimes.

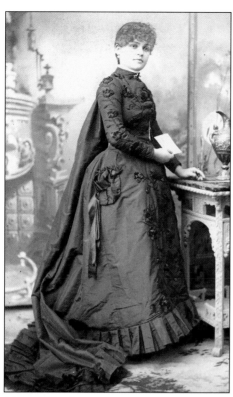

Belle Brezing is photographed in a black gown in the 1880s. Belle's reputation won her status as a madam in Lexington. The Lexington elite were frequent patrons of her bordellos, which made her a wealthy woman in town. (2003AV1 1.)

Belle Brezing is photographed in her private parlor at 59 Megowan Street, her third and most famous bordello, which was in operation from 1876 to 1917. (2003AV1 7.)

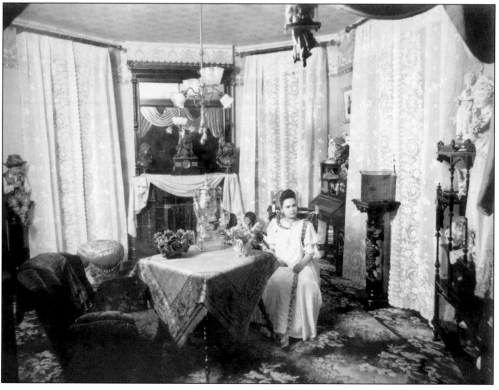

Leslie Carter was a local and national stage celebrity whose real name was Carolina Louise Dudley. She received international acclaim performing on Broadway in New York City and in London, England. (1997AV35 48.)

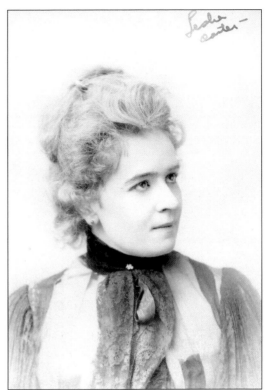

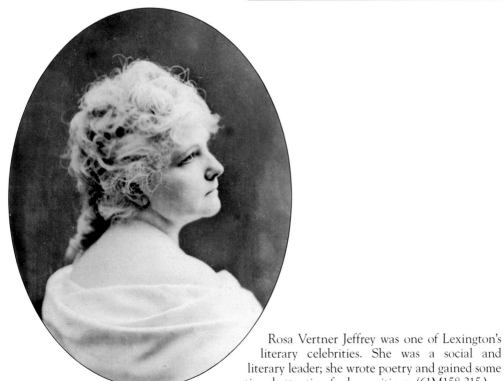

Rosa Vertner Jeffrey was one of Lexington's literary celebrities. She was a social and literary leader; she wrote poetry and gained some national attention for her writings. (61M158 215.)

43

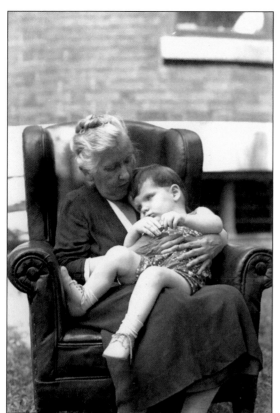

Linda Neville holds David Devary, a blind boy, in her lap. Linda Neville crusaded for the eradication of trachoma and other causes of blindness for nearly half a century. This picture was taken in 1938. (61M158 369.)

Marion Miley plays golf in 1941, shortly before her death. Miley won her first tournament at Big Spring in 1931 and continued to rise to the top through the 1930s. She earned five additional Kentucky titles. In 1941, armed burglars broke into the Lexington Country Club and fatally wounded Miley. In honor of the golfing star, the country club founded the Marion Miley Memorial Tournament. (2004AV001 5-907.08.)

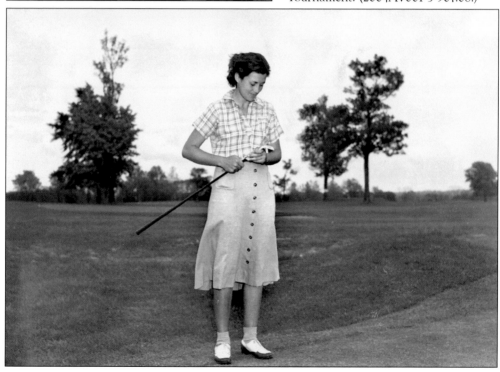

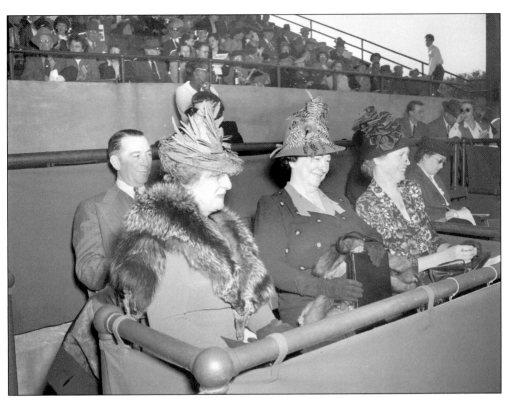

These spectators are photographed at the opening day of races at the Lexington Trots Breeders Association track in September 1946. Pictured from left to right are Viola Ransom, Pansy Yount, and Mrs. L. M. Winges. Pansy Yount was the owner of Spindletop Farm, which she enlarged to eventually encompass almost 1,066 acres and made a world-class American Saddlebred breeding facility. (2004AV001 2.01-2.03.)

Mary Sweeney was an internationally recognized authority on child development and welfare and was former assistant director of the Merrill-Palmer School. She was also head of the home economics department at the University of Kentucky, dean of home economics at Michigan State College, and executive secretary of the American Home Economics Association. A graduate of Transylvania College, Sweeney received an honorary degree from there in June 1949. (2004AV001 5-1257.01.)

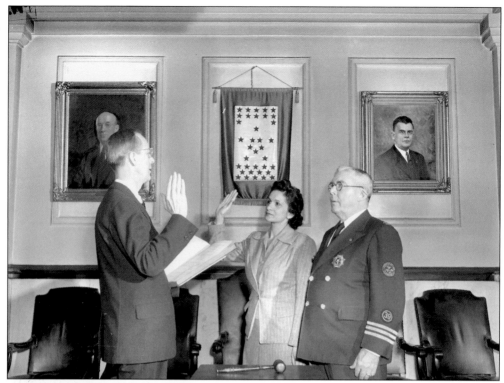

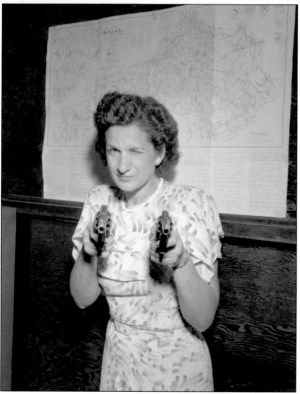

In February 1946, Ida Oplas was sworn into her post as Lexington policewoman. For most of her career, Ida worked with juveniles and checked the red-light district for runaways. In 1967, she was promoted to sergeant, becoming the first woman sergeant in Lexington. (2004AV001 5-973.02.)

Policewoman Ida Oplas is photographed holding two pistols. Oplas shot a perfect score on the seven-yard straight course. This picture was taken in July 1949. (2004AV001 1.04-917.)

Susan Garr was appointed by the city manager as policewoman to the Lexington Police Department in January 1949. Garr topped the list of applicants who took the civil-service examination for the position. She earned a bachelor of arts degree from Lemoye College in Memphis, Tennessee, and was also the director of the choir at Quinn Chapel. (2004AV001 5-503.)

Margaret Egbert cuts a slice of cake at her 92nd birthday party in July 1956. She was Lexington's first policewoman and retired from the force in 1946. The party was thrown by the Pioneer Business and Professional Women's Club (PBPW). Pictured from left to right are Allis May, membership chairman for the PBPW; Margaret Egbert; and Ann Lane Hostetter, president of the club. (2004AV001 M.1928.)

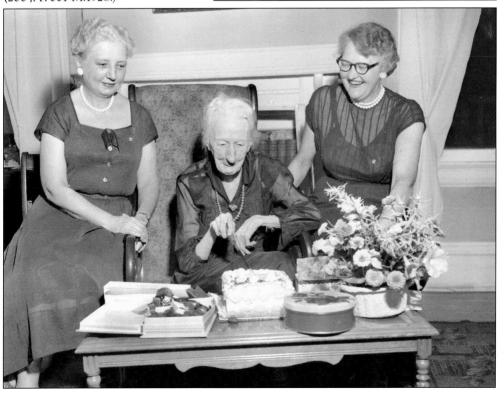

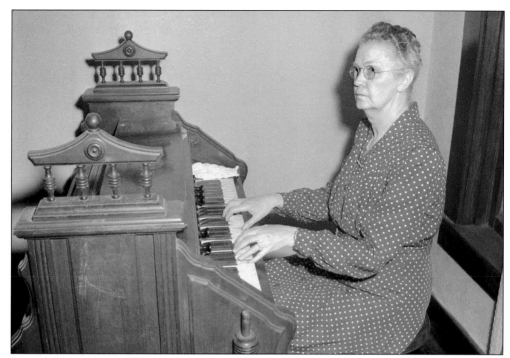

Mayme Cogar played the organ at Midway Baptist Church and was recognized for 50 years of service in March 1946. (2004AV001 1.13-204.)

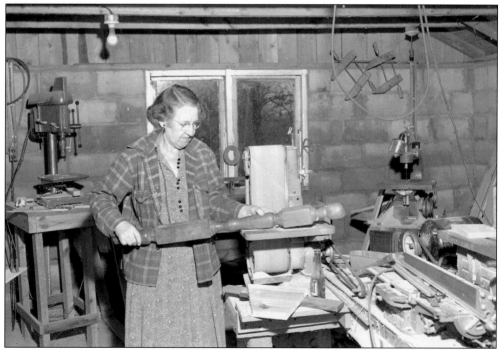

Mrs. J. C. van Arsdell, an expert cabinetmaker, stands beside her belt sander in the concrete-block workshop behind her home in April 1953. Some of her accomplishments include building four-poster beds, tables, and kitchen cabinets. (2004AV001 H.1014.)

Janet Anderson, editor of the University of Kentucky *Kernel*, was awarded the Fulbright scholarship for graduate study abroad and enrolled for a year's graduate work in journalism at the University of Glasgow, Scotland. This picture was taken in May 1951. (2004AV001 5-17.01.)

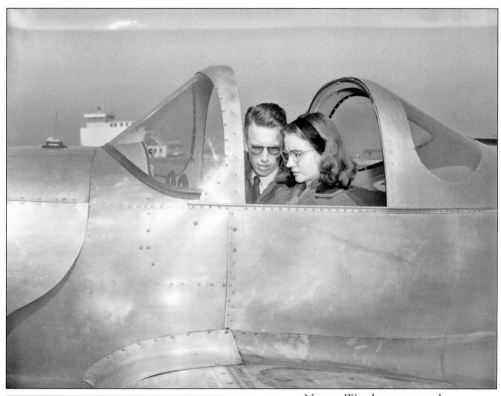

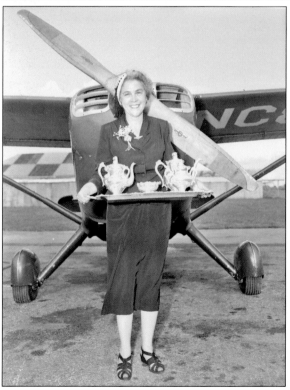

Norma Weatherspoon and Ben Gorham of the Bohmer Flying Service are pictured after Weatherspoon had her first experience flying a plane in February 1947. (2004AV001 1.02-106.01.)

Mrs. Greenwood Cocanougher was awarded a tea set after she won the Jane Lausche Air Safety Trophy in the Powder Puff and Beau Derby, an efficiency race for women from Columbus, Ohio, to Boston, Massachusetts, in August 1950. (2004AV001 5-255.)

Dr. Mary Jean Bowman was the only female member of the Social Science Research Council, a special committee formed to research business enterprises in the United States. She earned a bachelor of arts degree from Vassar and a doctorate from Harvard. Dr. Bowman was an author and a teacher; she worked for the government and served on a national committee of the American Association of University Women. This picture was taken in December 1953. (2004AV001 H.3141.)

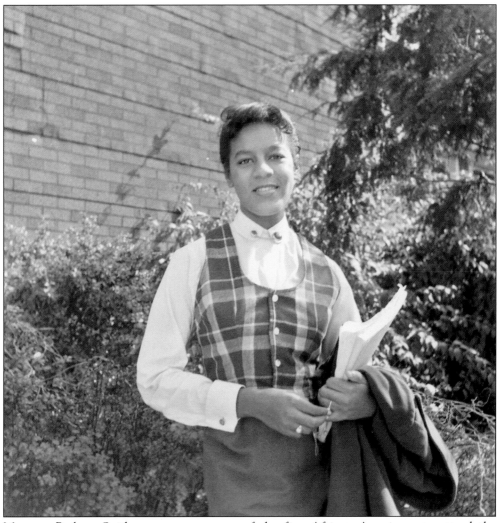

Maureen Barbara Strider was among some of the first African Americans to attend the University of Kentucky. Strider was a 1954 graduate of Dunbar High School and a pre-medicine major at the university. This picture was taken in October 1954. (2004AV001 J.2361a.)

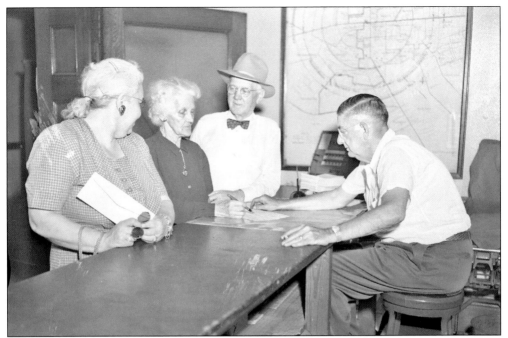

Lillian Johnson, 84, registers to vote for the first time in September 1955. Pictured from left to right are Mrs. Jeff Johnson, Lillian Johnson, Mr. Jeff Johnson, and Hugh Buckley behind the counter. (2004AV001 H.1413.)

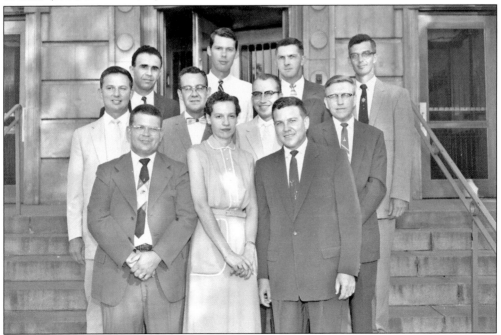

These were the new staff members at Good Samaritan Hospital in July 1956. Pictured from left to right are (front row) Dr. Elvis Thompson, Dr. Mary Fox, and Dr. Gene Watts; (second row) Dr. Bacon Moore, Dr. John Burris, Dr. Lewis Wesley, and Dr. Paul Smith; (third row) Dr. Suat Kora, Henry Spalding, Dr. Robert Blake, and Dr. Winston Burke. (2004AV001 M.1828.)

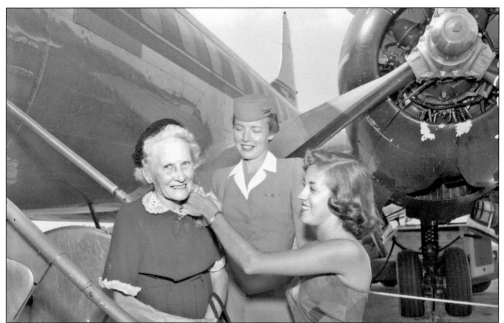

Sally Sutton, 70, receives a corsage from her great-niece, Maureen Tuttle, prior to leaving Blue Grass Field for her first airplane ride in September 1958. Stewardess Barbara Edenfield was waiting to escort Mrs. Sutton aboard her flight to Chicago. (2004AV001 P.2130.)

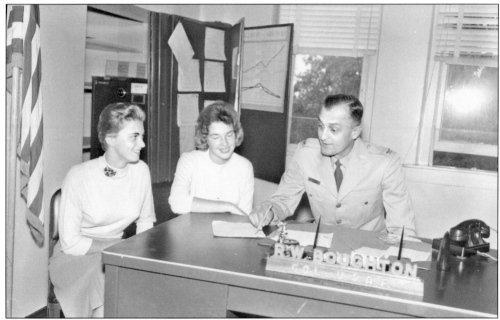

Brenda Steele (left) and Ann Corman (center) were the first University of Kentucky women to join the Air Force Reserve Officers Training Corps in September 1958. They are pictured discussing their pioneering venture into a traditionally male field—air science—with Col. R. W. Boughton, professor of air science and tactics. Although the women participated in the lectures with the men, they had to remain behind in the office to learn administrative duties while the male students moved onto the parade ground for drills. (2004AV001 P.2360.)

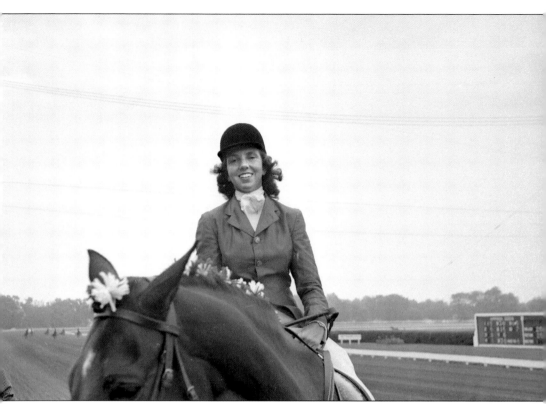

Jobie Arnold was the parade marshal for the Lexington Trots and was responsible for leading the way for the sulkies during the Trots meeting in September 1960. It is believed that she was the only woman horse handicapper in the country at that time. (2004AV001 Trots 1960A.)

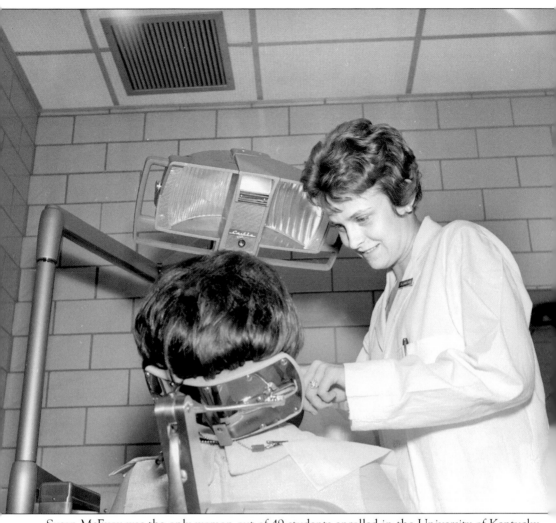

Susan McEvoy was the only woman out of 49 students enrolled in the University of Kentucky School of Dentistry. She is demonstrating some of the clinical practice that was part of the first-year curriculum while enrolled in June 1965. (2004AV001 W.1448.)

Four

SPORTS AND RECREATION

Recreational and leisure activities in Lexington were diverse and plentiful. Racing fans attended harness races at the Trotting Track and Thoroughbred racing at Keeneland. Area public and amusement parks offered other forms of entertainment. Women in Lexington played a variety of organized sports ranging from roller hockey to tennis, softball, basketball, bowling, and even football. Lexington has a history steeped in agriculture, as evidenced by the activity of girls and boys in area school agricultural fairs. Women were active in the arts, and many women enjoyed leisure activities that were unconventional for their era. Local universities and schools provided organized recreational activities. The following images depict classic team portraits, women in action, and some less conventional leisure activities like muzzle loading, the sport of firing muzzle-loading guns for target shooting or hunting.

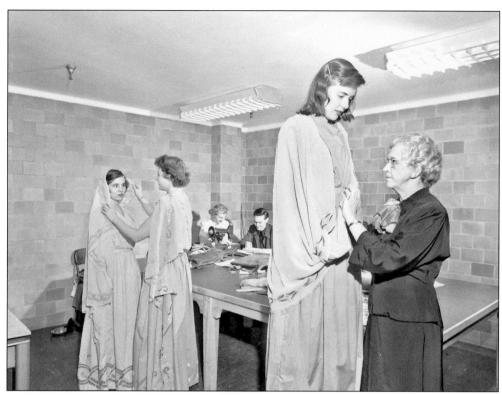

Anna Freeman (right) adjusts the dress on Priscilla Hancher in preparation for the Guignol Theater production of *Medea* in February 1950. Others in the picture from left to right are Ann Perrine, Ellen Drake, Mrs. Lolo Robinson, and Raymon Yancy. (2004AV001 1.05-149.01.)

Peggy Ann Adams and technical director O. G. Brockett work on backstage preparations for the Guignol Theater production of *Medea* in February 1950. (2004AV001 1.05-150.01.)

Lucille Little, the leading actress, is fitted for her costume by Anna Freeman in preparation for *Medea* in February 1950. (2004AV001 1.05-150.03.)

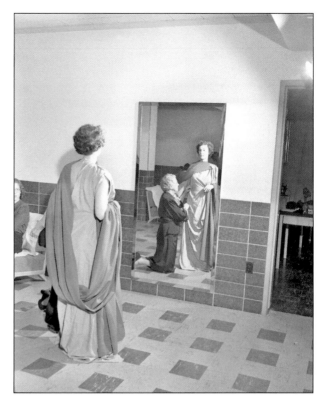

Marva Louis sits at a vanity before a fashion show sponsored by the Beta Gamma Omega chapter of Alpha Kappa Alpha sorority at the Lyric Theater in April 1950. (2004AV001 1.05-615.01.)

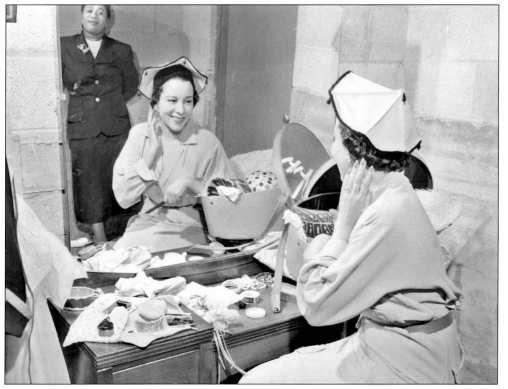

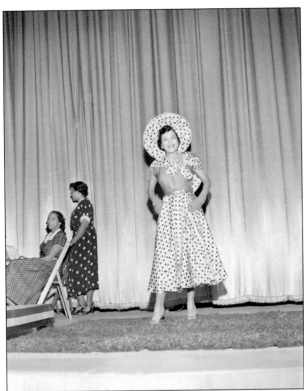

Marva Louis is seen onstage at the Alpha Kappa Alpha–sponsored fashion show at the Lyric Theater in April 1950. (2004AV001 1.05-615.02.)

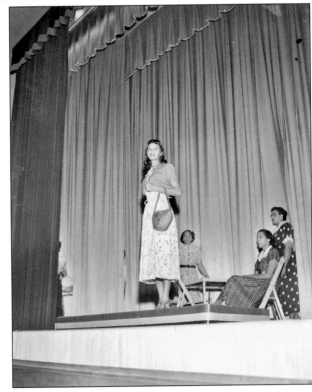

Mildred Barbour is pictured onstage at the fashion show sponsored by Alpha Kappa Alpha at the Lyric Theater in April 1950. (2004AV001 1.05-615.03.)

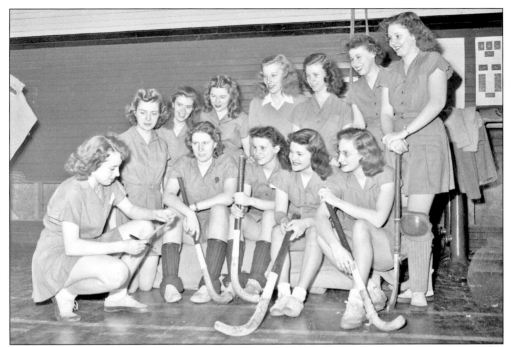

This is the 1945 University of Kentucky women's field hockey team. By the early 1920s, field hockey teams were sponsored by colleges and universities for women. (2004AV001 1.13-294.01.)

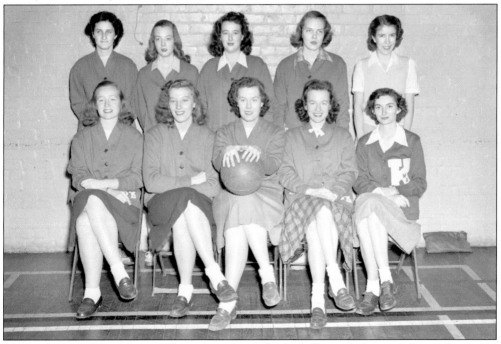

This is the 1947 University of Kentucky women's basketball squad. Pictured from left to right are (first row) Lola Stokes, Ruth Wilde, Betty Ree Rhodes, Margaret Wilson, and Betty Crowe; (second row) Margaret Winfough, Betty Jackson, Emily Asbury, Henrietta Avent, and coach Ann Lankford. (2004AV001 1.02-172.)

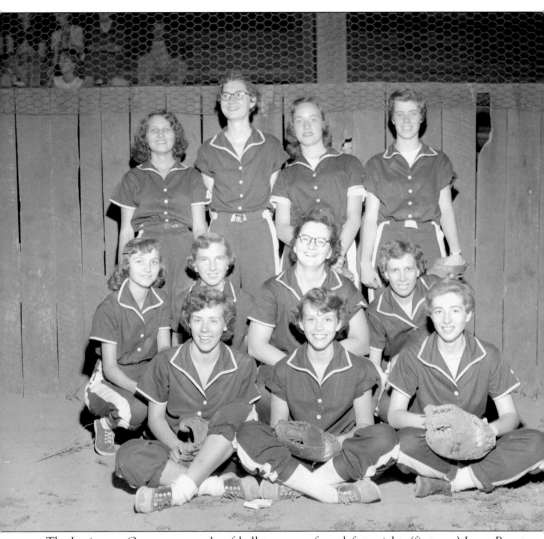

The Lexington Grocery women's softball team are, from left to right, (first row) Lynn Poynter, Shirley Lairson, and Betty Childers; (second row) Mary Lee Yates, Joyce Ritchey, Helen Hartshorn, and Jo Woolery; (third row) Inez Smith, Shirley Duncan, Pat Sewart, and Peggy McFadden. This picture was taken in August 1954. (2004AV001 J.1914.)

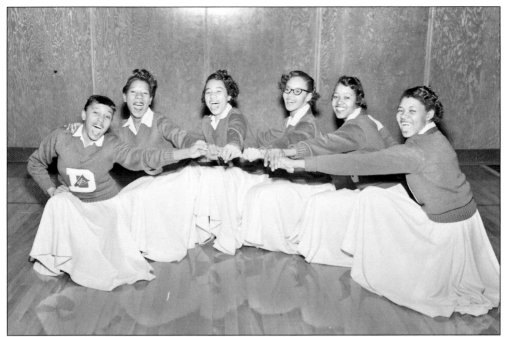

The 1957 Dunbar High School cheerleaders are, from left to right, Delores Passmore, Emma Coffey, Blanche Stokes, Darneal Johnson, Julia Johnson, and Georgia Woolfolk. (2004AV001 N.347.)

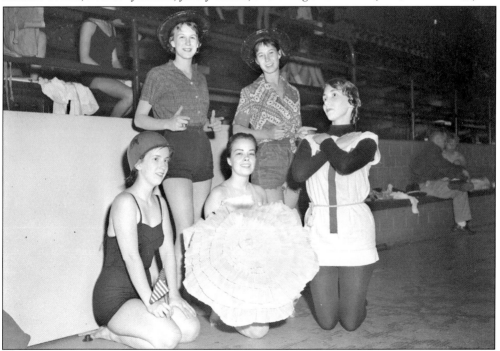

These are the 1961 members of the Blue Marlins, the University of Kentucky's women's swimming club, photographed while taking a break from the rehearsal of their annual show. Pictured from left to right are (first row) Molly Ryland, Evelyn Bridgforth, and Ann Finnegan; (second row) Carol Craigmyl and Diane Schorr. (2004AV001 S.707.)

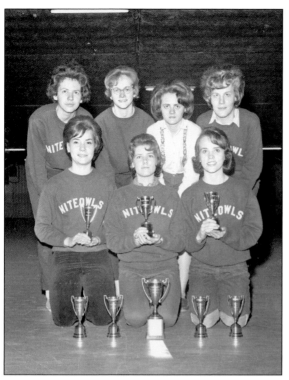

This is the Lexington championship roller-hockey team, the Niteowls, who were sponsored by E-Z Living Mobile Homes. Pictured from left to right are (first row) Connie Pottinger, Loraine Bresett, and Patty Voyles; (second row) Jo Ann Stewart, Terry Bussell, Brenda Finnell, and Jo Baldwin. This picture was taken in March 1963. (2004AV001 U.752.)

The 1963 members of the Douglass High School girls' basketball team are, from left to right, (first row) Earline Mullins, Phyllis Williams, Gwendolyn Hall, and Barbara Thomas; (second row) Barbara Hall, Joan Chenault, Bettie Hurt, Joyce Wright, Dorothy Maxberry, and Donna Hersey. (2004AV001 U.604.)

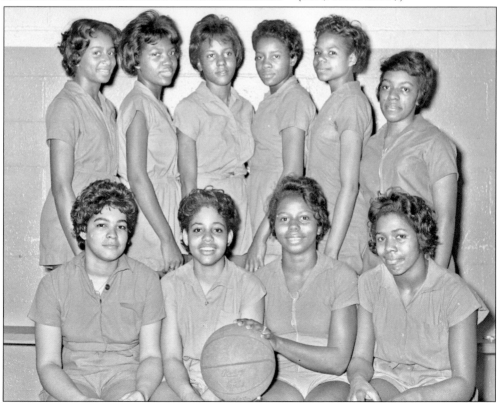

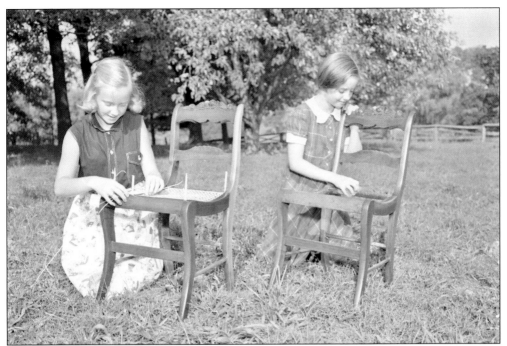

Alice Dudley Woods (left) and Margaret Woods work on chairs they are exhibiting at the Fayette County Youth Fair. They refinished the chairs and wove new seats for them in August 1954. (2004AV001 J.1944g.)

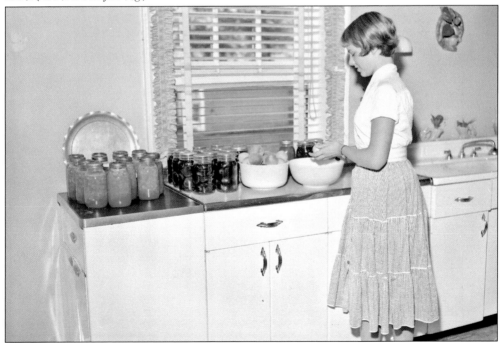

Janice Fister prepares peaches that she will can for display at the Fayette County Youth Fair. In addition to the peaches, Janice also displayed canned beets. This picture was taken in August 1954. (2004AV001 J.1944f.)

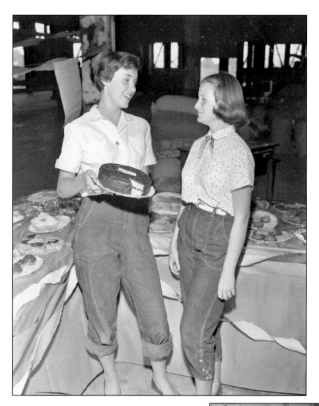

These are some of the winning contestants in the home economics exhibit at the Fayette County Youth Fair at the University of Kentucky Livestock Show Pavilion in August 1954. Sue Burton (left) won two red ribbons in baking and a blue ribbon in clothing. Jeannie Haines won a blue ribbon in clothing. (2004AV001 J.1944h.)

Lois Clasby (left) and Betty Garrigus look at frozen beans at the Fayette County Youth Fair in August 1954. Clasby won blue ribbons in canning, room improvements, and clothing, while Garrigus received blue ribbons for rolls and beans. (2004AV001 J.1944j.)

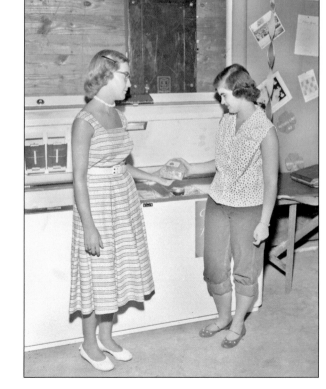

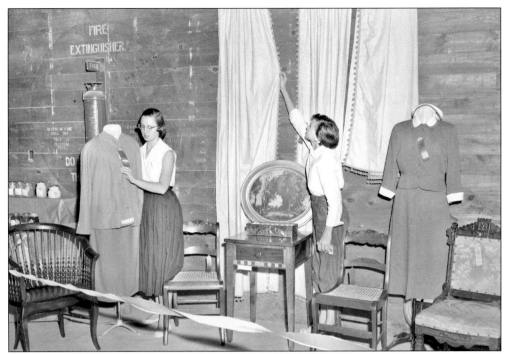

Marlona Ruggles (left) and Donna Burton check an exhibit on room improvement and clothing at the Fayette County Youth Fair in August 1954. Ruggles won a blue ribbon and Burton a red ribbon in clothing. (2004AV001 J.1944k.)

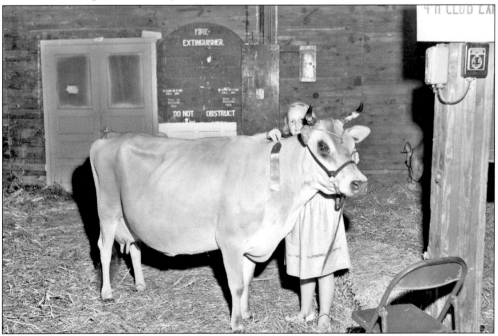

Linda Sue Saunders won the 4-H grand champion dairy prize in August 1954, despite the fact she could hardly look over the shoulder of the five-year-old cow she showed to win the prize at the Fayette County Youth Fair. (2004AV001 J.1944r.)

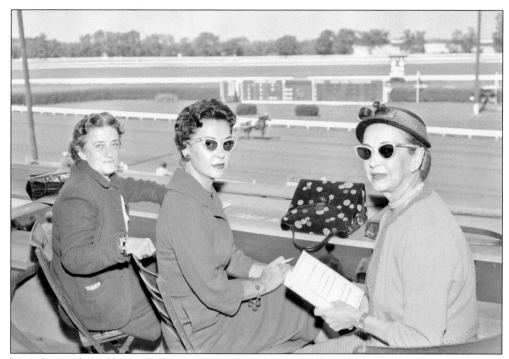

Mrs. Ormond McGlone, Catherine Horton, and Mrs. Fred Crapo were photographed at the opening day program of the 85th annual Trots at the Lexington Trotting Track in September 1957. (2004AV001 2.01-140.06.)

These three unidentified women admire a horse at the Lexington Junior League Horse Show in 1944. (2004AV001 2.02-3.04.)

Ruth Dudley Williams, Nell Dishman, Rebecca Edwards, Jane Melton, Manila Lyman, and Mrs. L. L. Essenbock were photographed while enjoying the fall races at Keeneland in October 1954. (2004AV001 2.03-154.02.)

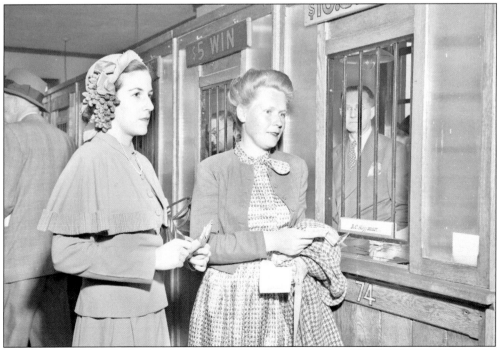

Mrs. Samuel Walton Jr. (left) and Mrs. Wickliffe Johnston wait to make their betting choices for the next race at Keeneland in April 1949. (2004AV001 2.03-59.02.)

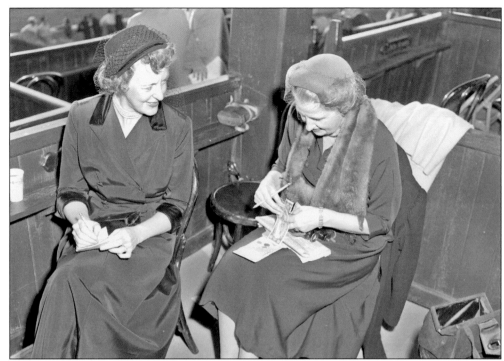

Mrs. Louis Williams watches Mrs. Marshall Pryor count her winnings at the end of the day's racing at Keeneland in October 1949. (2004AV001 2.03-69.04.)

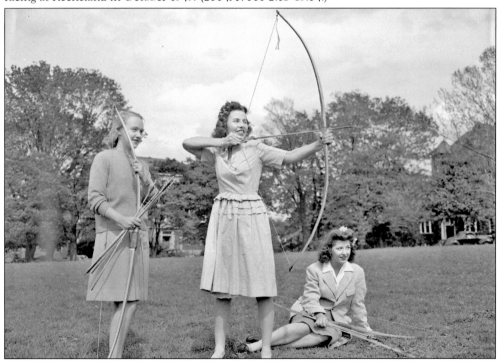

From left to right, University of Kentucky women Elizabeth Carey, Carolyn Gilson, and Anne Smith practice archery in April 1944. (2004AV001 1.13-19.)

Mrs. Elmer T. Gilb plays golf in the state women's tournament held at Idle Hour in June 1948. (2004AV001 5-520.01.)

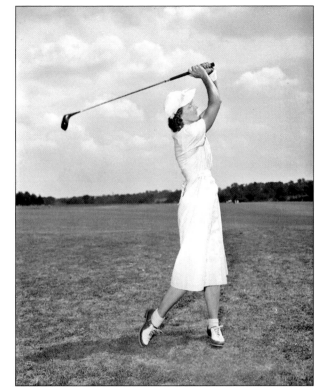

Schoolgirls play kickball at the Maxwell Street School. Young girls who may have once been considered tomboys were active participants in activities that were formerly delegated exclusively to boys at the school. This picture was taken in February 1949. (2004AV001 1.04-122.01.)

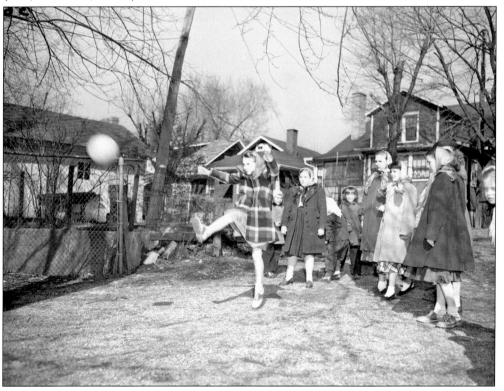

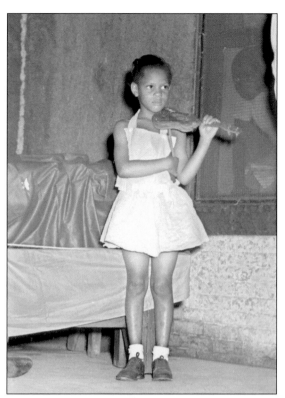

An unidentified female participant is pictured on stage for the play *Old King Cole*, which was presented at Douglass Park in August 1947. (2004AV001 1.02-810.01.)

The Manchester Street Library had been struggling with only one sewing machine, but as a result of a newspaper story, new machines were donated, increasing their total to four. Pictured working at the new machines are, from left to right, Ollie Burton, Joyce Spickard, Betty Wardle, Mary Margaret Barber, Mary Mai Wardle, and Eva Kidwell. This picture was taken in May 1949. (2004AV001 1.04-657.)

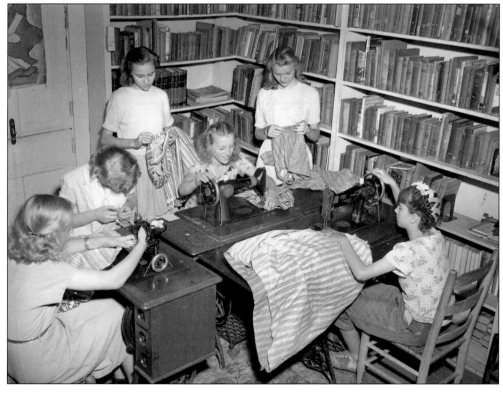

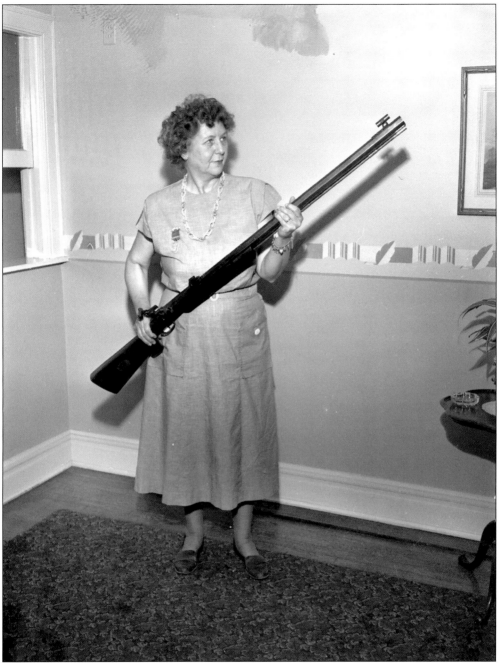

Annie Oakley has nothing on Mrs. J. Campbell Thomson, the wife of an expert Kentucky muzzle-loading rifle maker, who began muzzle shooting years earlier to familiarize herself with her husband's expertise. Thompson's interest began with her desire to understand what her husband was talking about when he discussed muzzle loaders. She went on to participate in a centennial observation, winning first prize over all the male entries with the gun pictured above. This picture was taken in August 1949. (2004AV001 5-1300.01.)

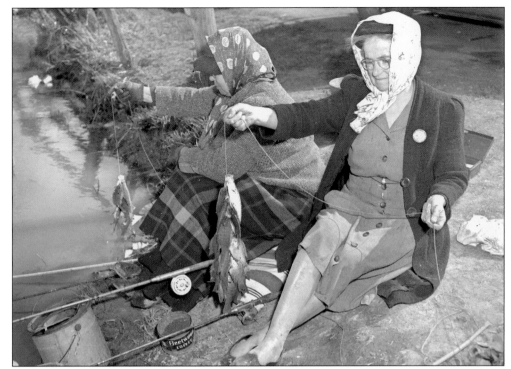

Susie Perkins (left) and Mae Alexander hold strings of fish they caught at the lake of the Lexington Water Company on Richmond Road. They are members of Lake Ellerslie Fishing Club. This picture was taken in April 1949. (2004AV001 1.04-430.)

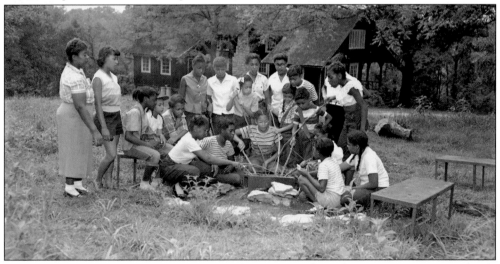

Girl Scout Troop 33, of the First Baptist Church, went on a three-day camping trip in April 1952 to Trail's End, a local Girl Scout camp off of Richmond Road. Seated closest to the campfire are, from left to right, Alberta Parks, Joann Clark, Darneal Johnson, Arnetta Arthur, Delores Williams, and Janice Miller. Grace Harris, standing at the far left, was the troop leader; she was assisted by Winston Jackson. The other campers include Jo Ann David, Betty Ann Davis, Eleanor Wigginton, Betty Berryman, Anna Long, Josephine Smallwood, and Ann Spiller. (2004AV001 G.1816.)

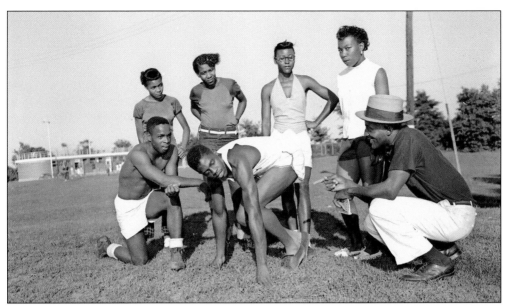

Young women prepare for a track meet at Douglass Park in July 1953. Pictured in front from left to right are George Johnson, a college sophomore; James Taylor, a junior at Kentucky State College; and John W. Brown, the executive director of Douglass Park. The three men were demonstrating some of the points of starting in a track meet to, standing from left to right, Alice Garrison, Bonnie Johnson, Mary Price, and Arizona McDermott. (2004AV001 H.1941.)

These Manchester Center girls appeared in a ballet at the Community Chest open house in October 1953. Pictured from left to right are (on the floor) Carolyn Kidwell, Patricia Reaves, June Davis, Phyllis Davis, and Johnnie Gilbert; (standing) Madge Worsham, Emma Davis, Patsy Parker, Judy Marcus, Johnny Tudor, Ernestine Lamb, and Betty Marcus. The girls studied ballet with University High student Laura Russell (not pictured). (2004AV001 H.2522.)

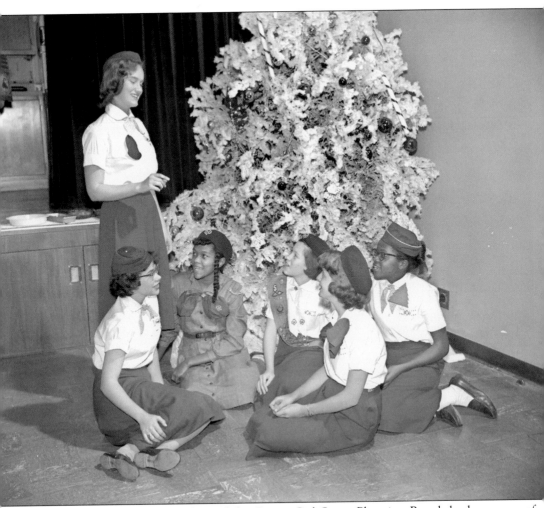

Gae Good (standing), president of the Senior Girl Scout Planning Board, leads a group of carolers at a rally in December 1955. Pictured from left to right are Lois Ann Greathouse, Sandra Berry, Ada Wilson, Bennie Harrison, and Martha Burdett. (2004AV001 K.2835.)

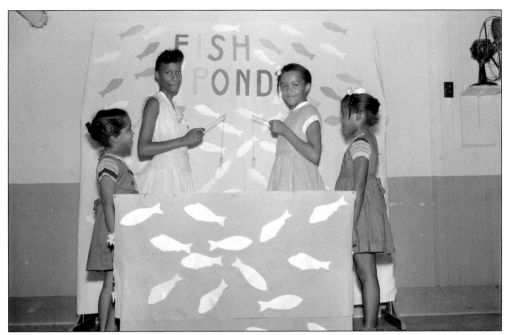

The First Baptist Church sponsored a carnival that featured a country store, a movie, a house of horror, and a review in September 1957. Making preparations for the carnival are, from left to right, Rosemary Young, Sandra Wilson, Phaon Lewis, and Rosanna Young. (2004AV001 N.2463.)

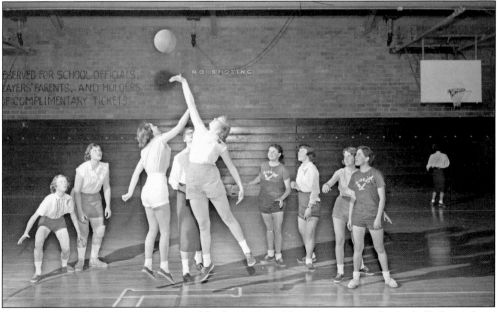

During a sports day program, sponsored by the Girls Athletic Association, basketball players from Bryan Station, Morton, and Lafayette High Schools in Lexington and from Pinkerton High of Midway played basketball at the Lafayette Gym. Waiting for a tip from Helen Thomas (left center) or Geneva Murray (right center) are, from left to right, Gayle Owens, Joyce Florence, Janice Burton, Sue Miller, Billie Parsons, and Marian Barreiro. The referee was Shirley Duncan, pictured between Thomas and Murray. This picture was taken in April 1955. (2004AV001 K.962.)

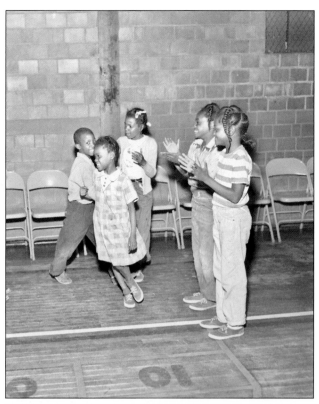

Square dancing was part of the demonstration of physical, mental, social, and creative activities at the Charles Young Community Center in April 1956. Some of the participants are, from left to right, Spencer Lindsay, Emma Smith, Jacqueline Lindsay, Janet King, and Ledoris Shields. (2004AV001 M.1037.)

From left to right are Helen Benton, Henrietta Lewis, and Martha Edmonds, who were contestants in a bathing beauty contest at Douglass Park in July 1958. (2004AV001 P.1821.)

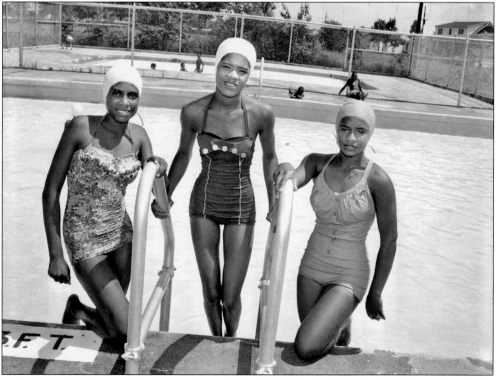

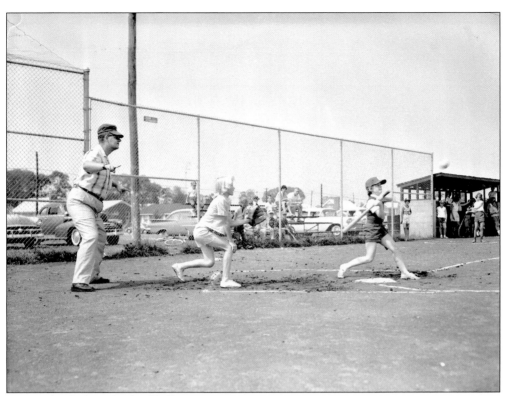

During the daylong final softball tournament of the summer, umpire Don Laio calls a strike on Lana Mulls, a member of the Meadowthorpe Beatniks softball team. The catcher for the Southland Park team is Sharon Page. The tournaments closed the Fayette County Recreation Department's summer activities in August 1960. (2004AV001 R.2028.)

This unidentified young girl attended the 12th annual Fraternal Order of Police Halloween Party at the Charles Young Community Center in October 1960. (2004AV001 R.2695b)

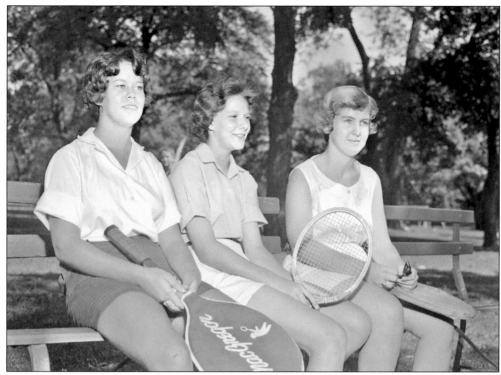

These three local girls entered the Lexington Junior tennis tournament, sponsored by the Blue Grass Tennis Association, but they were unable to play because of insufficient entries. Pictured from left to right are Patty Wade, Kathy Warford, and Virginia Boyd. This picture was taken in August 1962. (2004AV001 T.2266.)

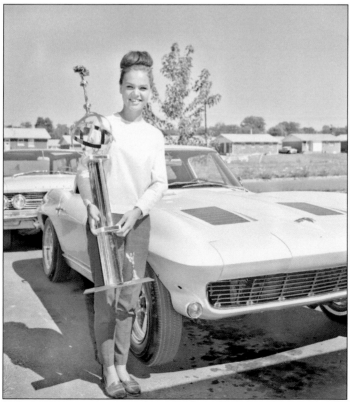

Pictured here is Mrs. David Ranck with the prize she received after bringing a recently acquired Sting Ray in first at the Mountain Parkway Drag Strip near Clay City. By 1964, more Kentucky women were participating in the sports of stock car and drag racing. (2004AV001 V.2347.)

Five

COLLEGE AND SCHOOL LIFE

The University of Kentucky (then the Agricultural and Mechanical College of Kentucky and called State College) pushed coeducation for men and women in 1880. Kentucky University (now Transylvania University) had been an all-male institution since its founding in 1780. Transylvania was slightly more resistant, but ultimately they opened their doors to women in 1889. Women entered the university in steadily increasing numbers. Many women have contributed to the improvements of Fayette County schools. Madeline McDowell Breckinridge helped to educate immigrants who came to Lexington for work in the late 19th century. In 1905, when Nannie Faulconer was superintendent, she initiated a transportation system and a vocational education program. Numerous other women have had key roles in the progress of education for both men and women of Fayette County. The following images document women at universities and girls at area schools, in classes, and in clubs.

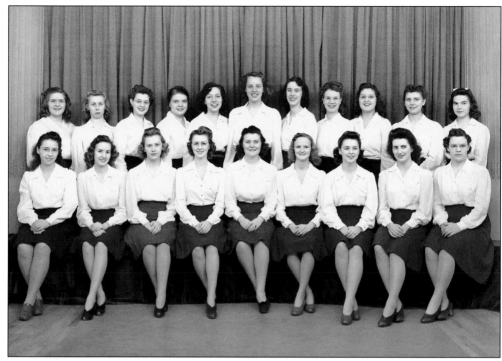

This is a group portrait of Crimson, the Women's Independent Group at Transylvania College. This picture was taken in February 1942. (96PA101 4838a.)

Transylvania College freshman George Hard Jr. assists Neccmiye Illeri with her move into Forrer Hall, the new women's quarters, in October 1958. (2004AV001 P.2382a.)

Transylvania College coeds Charlotte Ingram (left) and Joyce Thaman fill their built-in chests with sweaters in their new room at Forrer Hall in October 1958. (2004AV001 P.2382b.)

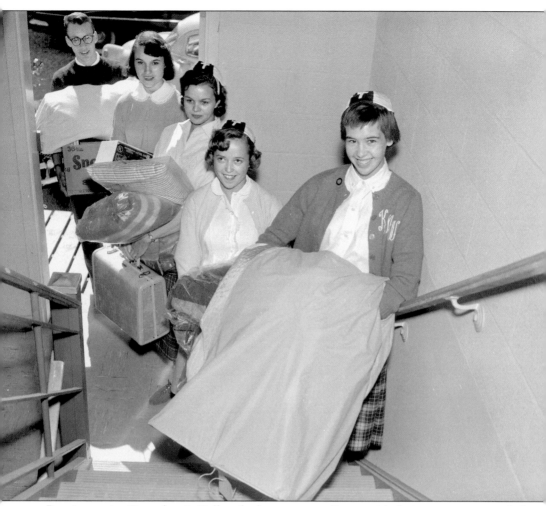

Beanie-wearing Transylvania College freshman women line up with their new campus wardrobes on move-in day to Forrer Hall in October 1958. Pictured from left to right are unidentified, Joy Stinnett, Betty Ann Snyder, Ritchey Eldred, and Kitty Winkler. (2004AV001 P.2382c.)

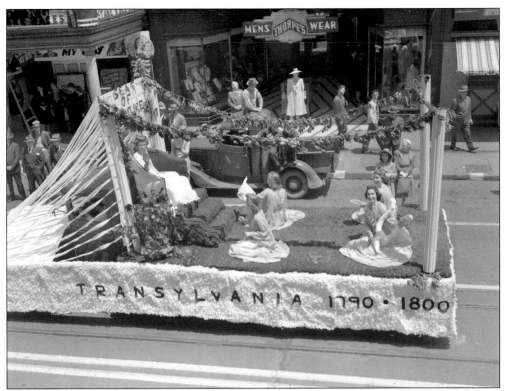

This parade float in honor of Transylvania Day was photographed in downtown Lexington in 1940. Transylvania Day was celebrated each spring by students and faculty to honor Lexington's oldest institution of higher learning. (2004AV001 1.13-570.11.)

Twelve University of Kentucky freshmen women wear the institution's frosh cap, which until 1949 had been required equipment for men only. Pictured from front to back are Frances Maxedon, Soula Margaratis, Mary Lou Gover, Kizzie Roberts, Doris Morgan, Ruth Ann Maggard, Mary Ella Walter, Nancy McGuire, Ann Brittingham, Phyllis Jean Ewen, Marilyn Miller, and Molly McCoulf. (2004AV001 1.04-1292.02.)

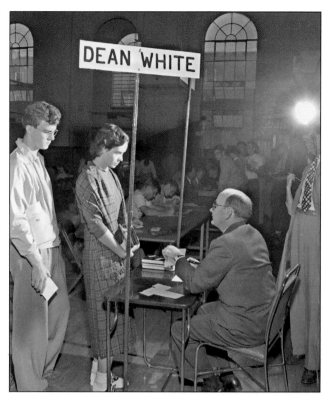

Pat Moore enrolls in her classes with Dean M. M. White, who assisted Moore with the selection of subjects necessary for a degree in the Arts and Sciences College. Moore was photographed at Alumni Gymnasium during freshman orientation at the University of Kentucky in September 1949. (2004AV001 1.04-1294.04.)

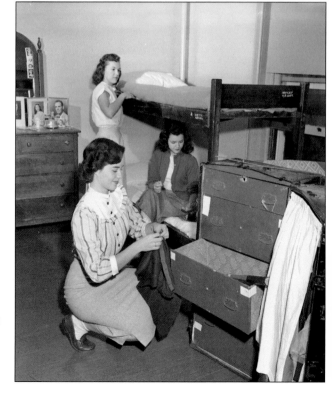

During their spare time at the 1949 University of Kentucky orientation week, freshmen women prepare their new living quarters. Pictured are Pat Moore unpacking her clothes, Mary Jo Cundiff polishing her nails, and Marian Ferguson making the bed. (2004AV001 1.04-1294.03.)

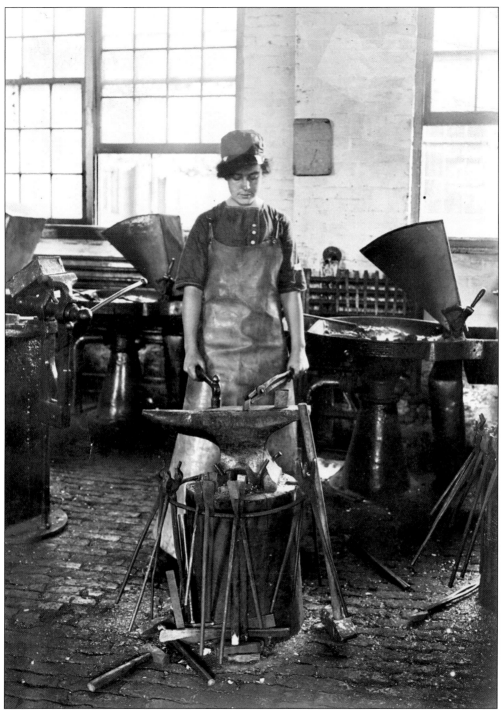

Margaret Ingels worked in the mechanical engineering field for 32 years, a profession mostly dominated by men. She is pictured standing behind a forge preparing to work at the University of Kentucky Engineering Department in 1916. (UA107 18.)

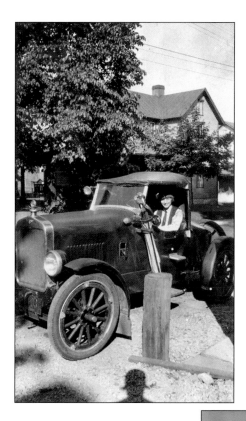

Helen Cochran was a student of the State University of Kentucky Engineering Department. She is pictured sitting in a Ford Model A, which was called "Miky Ingels," in 1930. (UA107 67.)

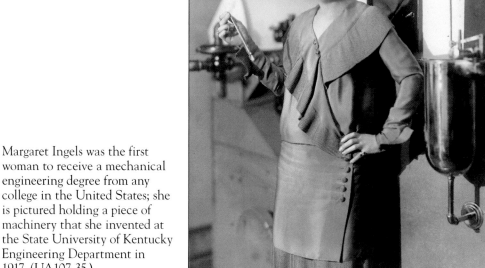

Margaret Ingels was the first woman to receive a mechanical engineering degree from any college in the United States; she is pictured holding a piece of machinery that she invented at the State University of Kentucky Engineering Department in 1917. (UA107 35.)

Margaret Ingels, 11 years after her retirement from the field of mechanical engineering, was credited by her last employer, the Carrier Corporation, as being an authority on air conditioning and refrigeration. It was said of her, "She did so much in its early forming years to inform the American public, particularly the women, about the advantages of air conditioning." This picture was taken in February 1963. (2004AV001 U.409.)

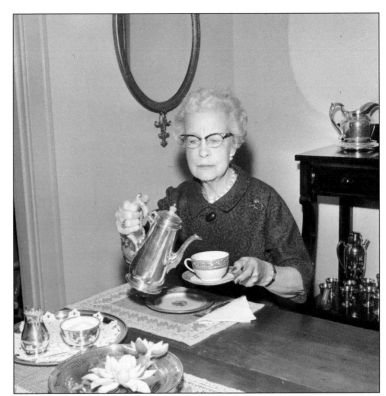

Sarah G. Blanding, president-elect of Vassar College, and her mother, Mrs. William D. Blanding, are photographed at their home on South Broadway in March 1946. Blanding, a 1923 University of Kentucky graduate, became Vassar's first woman president. (2004AV001 5-99.01.)

These women attended the dedication of Blazer Hall, the University of Kentucky women's dormitory, in October 1962. Pictured from left to right are Dr. Doris M. Seward, dean of women; Dixie Evans, director of women's residence halls; Georgia M. Blazer; and Sarah B. Holmes, dean of women emeritus. The dormitory was named for Georgia Blazer in recognition of her 22 years of service as a University of Kentucky trustee. (2004AV001 T.2706.)

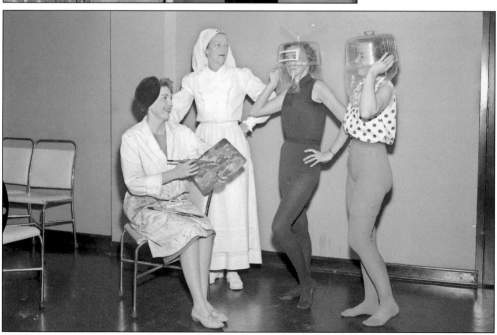

The University of Kentucky Woman's Club celebrated its 50th anniversary in May 1960. In honor of the celebration, the members dressed to represent women of different eras. Pictured from left to right are Mrs. Baker, the artist; Mrs. Clifford Amyx, World War I nurse; and Mrs. William A. Kendall and Mrs. T. J. Pignani, space-age club members. (2004AV001 R.1325.)

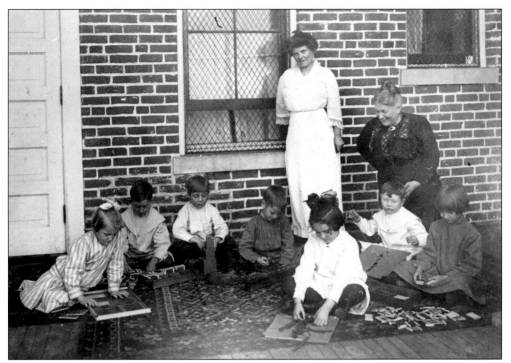

These Picadome Montessori students are photographed *c.* 1910 with Belle McCubbing, right, and Nannie Faulconer, standing. (2003AV011 199.)

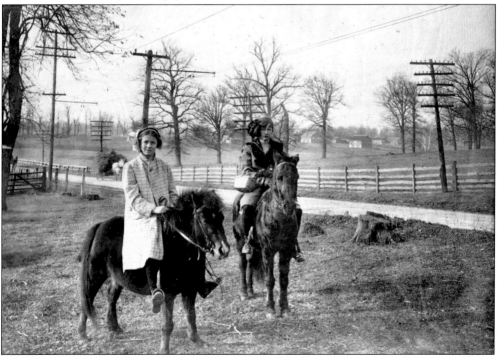

These unidentified Fayette County students frequently rode their ponies to school around 1910. (2003AV011 194.)

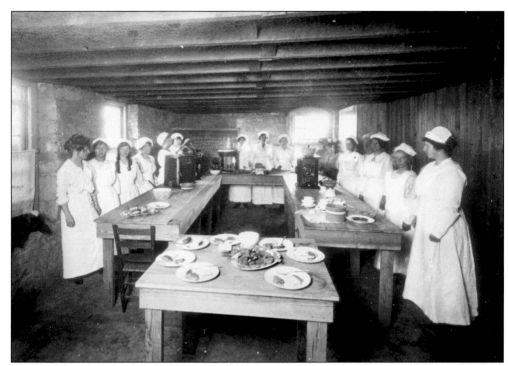

These unidentified Athens schoolgirls were photographed in a cooking class around 1910. (2003AV011 203.)

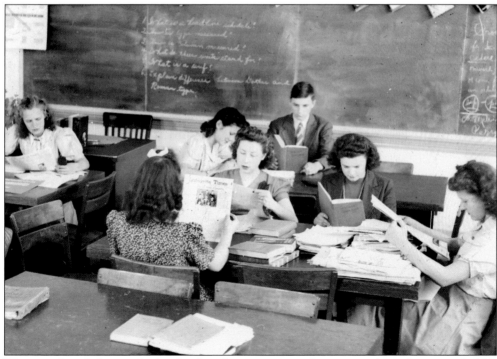

These unidentified senior high school students are pictured in a journalism class around 1930. (2003AV011 299.)

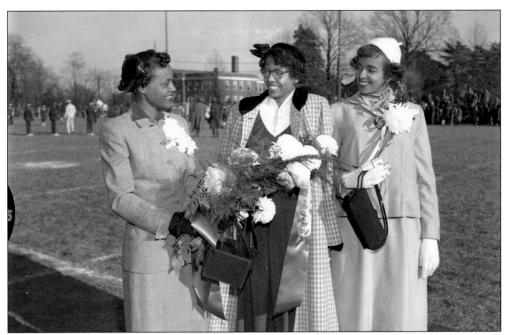

Doris Wilkinson (center) was crowned during halftime as the 1952 Douglass High School homecoming queen. She is pictured with Juanita Williams (left), the 1951 homecoming queen, and Earlyse Brown, runner up. (2004AV001 G.2481.)

Lexington high school students receive an on-the-job view of nursing in March 1956. From left to right are Barbara Collett, Sheila Keller, Ruth Ann Ownbey, and Esther Warden, among the 61 Lexington girls who participated in the Women's Auxiliary of the Fayette County Medical Society recruitment program. The primary aim of the program was to show the girls what the career offered and what it meant in terms of work and study. (2004AV001 M.510.)

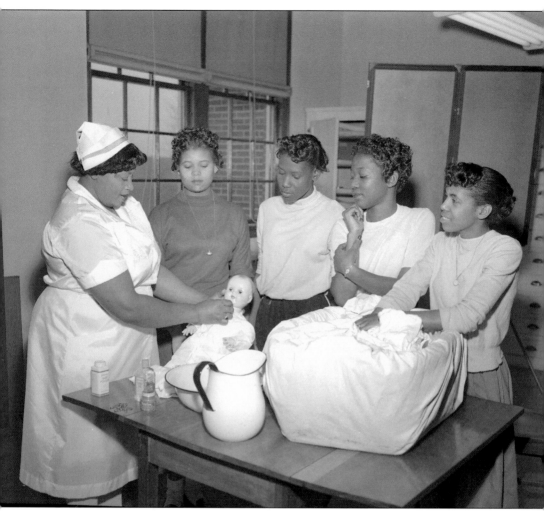

Douglass High School students learn baby-care techniques in February 1957. The techniques are demonstrated by Fannie Foster, a licensed practical nurse and Red Cross nurse instructor, to members of a Red Cross home care of the sick class at Douglass High School. Pictured watching, from left to right, are Loretta Beatty, Charles Anna Brown, Delores Edwards, and Carolyn Jackson. (2004AV001 N.357.)

These unidentified students were photographed in the gymnasium class at Bryan Station High School in December 1933. (96PA101 1829n.)

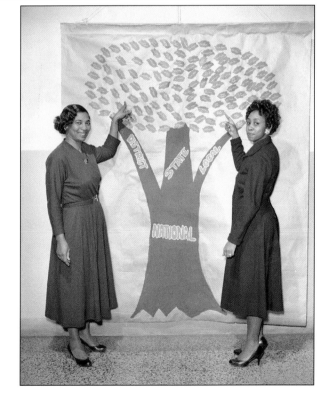

Mrs. George Spotts (left), safety chairwoman, and Mrs. Curtis Shores, president, stand with a display depicting the spirit of PTA in February 1958. The tree was used in a PTA program where each leaf represented one of the 124 individual members. (2004AV001 P.485.)

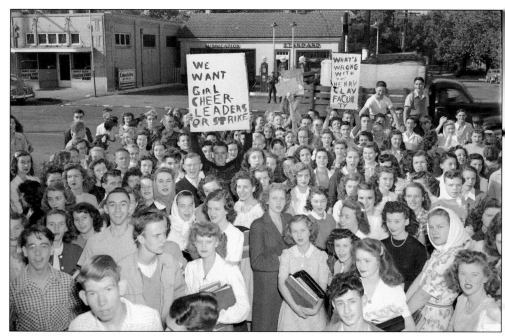

Henry Clay High School students arrived early to school to demonstrate their desire to have girl cheerleaders in September 1946. The students were invited to assemble in the auditorium and express their views on the subject. (2004AV001 1.01-246.01.)

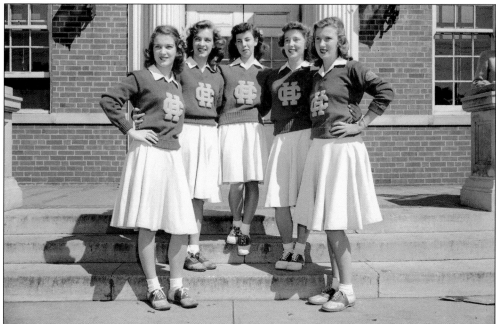

A committee of faculty members and students selected, from left to right, Doris Walker, Betty Peck, Edie McLendon, Patty Wilkinson, and Faye Fitzgerald to lead the student body in cheers for the Blue Devils at Henry Clay High School. The school had previously been denied female cheerleaders because of a faculty ruling. This picture was taken in October 1946. (2004AV001 1.01-291.)

Mary E. Short (left) and Jeanne Reynolds talk with J. Frank Adams, state editor of the *Lexington Herald*, in May 1949. The two young women from Lafayette High School ranked high in a creative writing and journalism test given by the school and the State Employment Service Division office. They toured the newspaper and watched the paper being published. (2004AV001 1.04-661.)

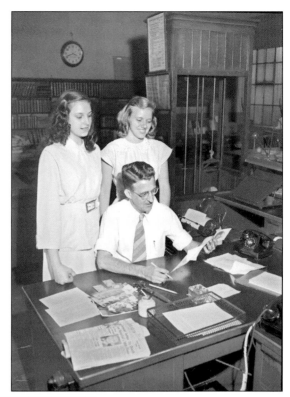

Douglass High School reporters, from left to right, Olivia Owens, Wanda Ross, and Lula Morton were honor students and active in many school activities at Douglass. This picture was taken in May 1960. (2004AV001 R.1279.)

Henry Clay High School students take a driving class sponsored by the Bluegrass Automobile Association and the Lexington Police Department in September 1948. Pictured from left to right are Bobby Cain, Pearl Woolery, Betty Smith, Jo Ann Robinson, and patrolman William Sellers. (2004AV001 1.03-1052.01.)

Virginia Lee Mullins (center), a fourth-grade student at Carver School, was the top winner in the Fire Prevention Week poster contest in October 1962. Awarding her the prize are Mrs. Robert B. Congleton and fire inspector Tom Parker. (2004AV001 T.1139.)

The University High School girls' choir sings onstage. Also pictured are Ruth Stallings, the director, and Helen Hutchcraft, the accompanist, in December 1948. (2004AV001 1.03-1397.01.)

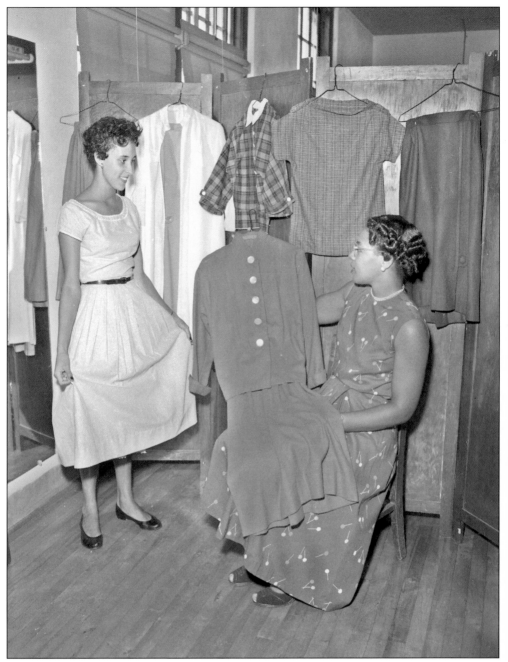

Mary Elizabeth Mayfield of Douglass High School models a dress in 1956 for Lila Rankin, her home economics teacher. Mary was an accomplished seamstress, and through Douglass High School teachers' sponsorship, the senior was chosen for the 1957 McCall's Pattern Teen Fashion Board. (2004AV001 M.3050.)

Six

COMMUNITY INVOLVEMENT

Prior to the 19th century, many women's associations were church sponsored or were auxiliaries of men's organizations. While women still played active roles within these organizations, the direction was still largely controlled by men. Early on, most club members were those who had the leisure to commit their time and energy, and clubs were dominated by women of social status. While it is true that many of these women were able to contribute their time based upon their social or economic status, women of all economic levels were truly committed to enriching their community through volunteerism. The community work that all women in Lexington performed was a valuable contribution to the people of the area. They raised funds for polio, committed to local charities, and provided their time and support to many local and national causes including politics, charitable organizations, and community enrichment programs.

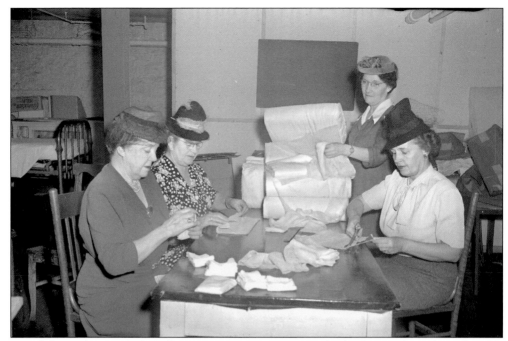

From left to right, Mrs. R. J. Colbert, Mrs. M. J. Cronin, Mrs. Charles F. Greis (president of Health Center Aid Society), and Mrs. J. Winston Coleman were Lexington women who worked at the Public Health Center on 227 North Upper Street in February 1946. (2004AV001 1.13-290.)

These are 2 of more than 100 Lexington women who were honored with certificates of recognition for 200 or more hours of volunteer work. Pictured are Mrs. Rhodes Hart (left), a dietitian's aide, and Joyce Hopkins, a nurses' aide. The award was presented by Clinton M. Harbison, chairman of Lexington Red Cross chapter, in May 1946. (2004AV001 1.13-236.)

Lexington Girl Scouts attend a folk festival tea at Arlington School to make a contribution to the Juliette Low World Friendship fund for rehabilitation of war-damaged countries in March 1947. Pictured from left to right are Mrs. W. S. Taylor, chairwoman of the city fund; Mary Jo Hutchens; Ellen Marie Carr; and Helen Kloosterman. The Scouts were members of Troop 3 at Russell Cave School. (2004AV001 1.02-151.)

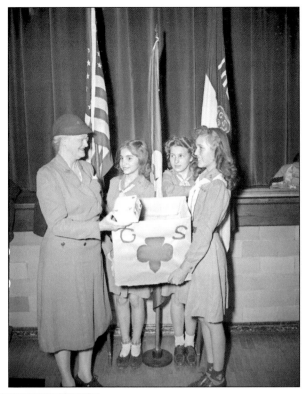

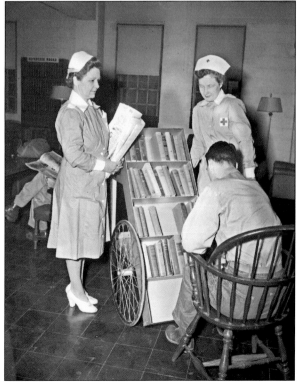

Mrs. Frank McCarthy (left) and Mrs. R. E. Culbertson, gray ladies at the Veterans Administration Hospital, aid a patient in selecting a book from a wheeled library shelf in March 1947. In addition to this portable unit, there was a well-stocked library at the hospital. The Gray Ladies group was one of the projects aided by funds from the Lexington chapter of the American Red Cross. (2004AV001 1.02-185.)

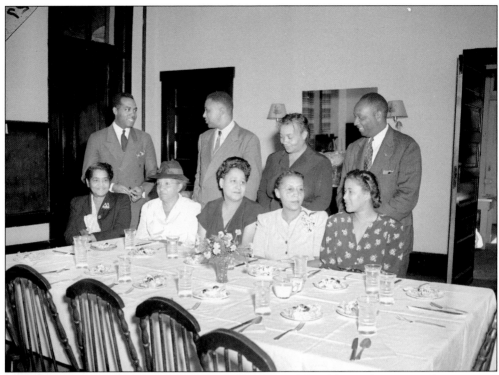

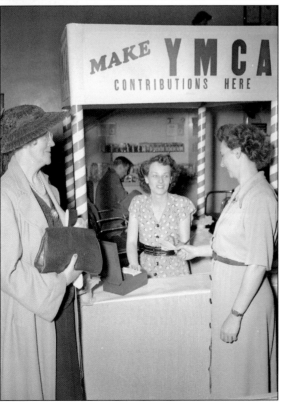

The African American solicitation division of the Community Chest met in October 1947 to plan details of their fund drive. Pictured from left to right are (seated) Lucky Hart Smith, chairwoman, special gifts committee; Lydia Searcy, captain, Coletown; Ethel Taylor, co-chairwoman; Shirley Hardy, captain, West End; and Lizzie Johnson, YWCA executive; (standing) U. S. Fowler, division chairman; A. R. Howard, captain, central district; Elizabeth Moody, assistant captain; and Clifton Coleman, captain, South End. (2004AV001 1.02-1005.01.)

From left to right, Mayme Darnaby, Mrs. Floyd West (saleswoman recording contributions), and Rosamond McAlister are pictured at the YMCA booth in a Sears, Roebuck and Company store. The booths were operated in May 1948 at downtown retail stores, theaters, the post office, and the courthouse to receive cash or pledges for the YMCA building fund campaign. (2004AV001 1.03-600.)

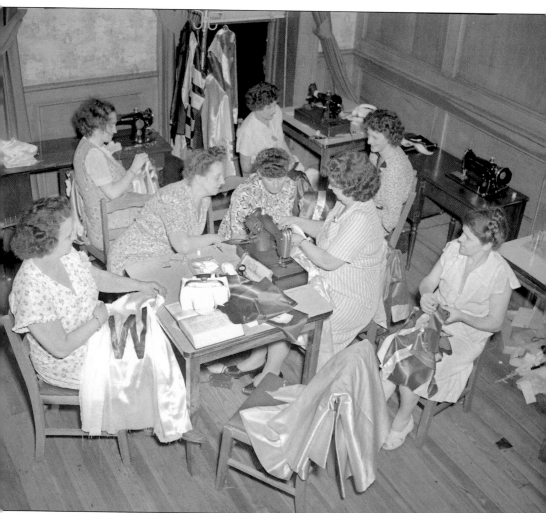

In August 1947, (from left to right) Mrs. Edward W. Howard, Mrs. Albert Owens, Mrs. E. F. Jacobs, Mrs. Fred Moilan, Mrs. Henry Hettel, Ann Dearing, Mrs. Warren Osborne, and Mrs. Tom C. Smith sewed uniforms for the drum and bugle corps of the American Legion, Man O' War Post. To insure their chances of bringing back a national prize from the convention in New York City, women of the post prepared unique jockey silks, the official uniform of the corps. (2004AV001 1.02-753.)

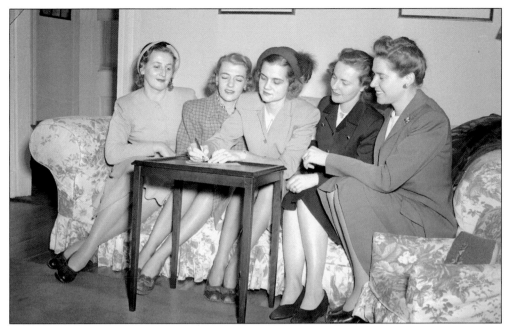

The Lexington Junior League prepares a check for the Isolation Ward Fund. Pictured from left to right are Mrs. John W. Marr, Mrs. Frazee Wilson, Mrs. James E. Ireland, Mrs. Hendree Milward, and Mrs. Nat Hall. The horse show began in 1937, serves as the Junior League's only fund-raiser, and has become a prestigious event in the Saddlebred industry. This picture was taken in January 1948. (2004AV001 2.02-28.)

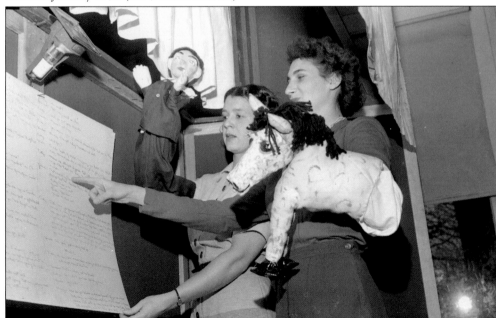

The Lexington Junior League puppet show, *Nestor, the Talking Horse*, was presented in January 1948 at local hospitals to benefit disabled children. The Junior League of Lexington was founded in 1924 by 10 women dedicated to volunteerism and the improvement of the Lexington community. (2004AV001 1.05-2270.)

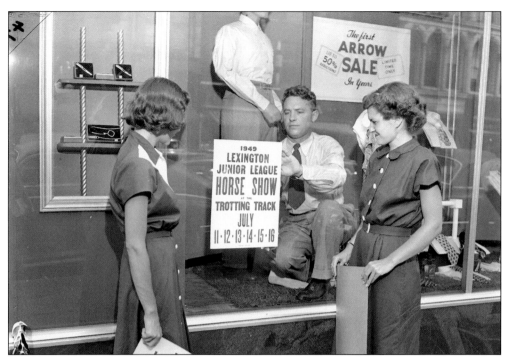

Joyce Harris (left) and Sally Forman, members of the Junior League, watch as Howard Platt, advertising manager for Graves-Cox, places an announcement for the Lexington Junior League Horse Show in the store's window in July 1949. (2004AV001 2.02-29.)

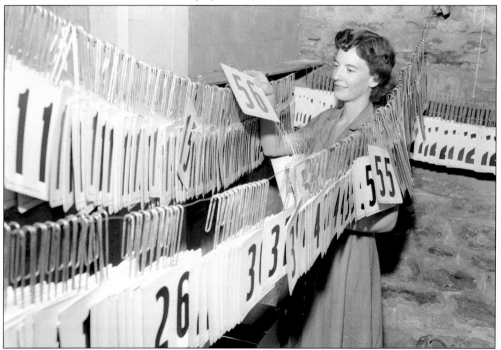

Mrs. Gayle Alexander, a member of the office committee for the Lexington Junior League Horse Show, sorts numbers for the horse show exhibitors in July 1950. (2004AV001 2.02-43.02.)

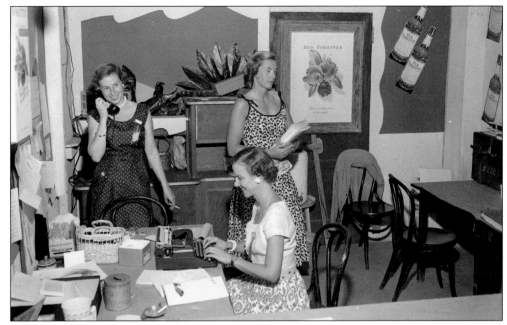

These Junior League members worked in the office during the horse show and were on duty to give out information to exhibitors and other visitors, to record the results of the various classes and stakes, and to answer the numerous telephone calls that came in for spectators at the show. Pictured are Lucille Scott at the typewriter, Waller Jones on the telephone, and Greta Rogers retrieving a new supply of horse show programs. This picture was taken in July 1953. (2004AV001 2.02-82.03.)

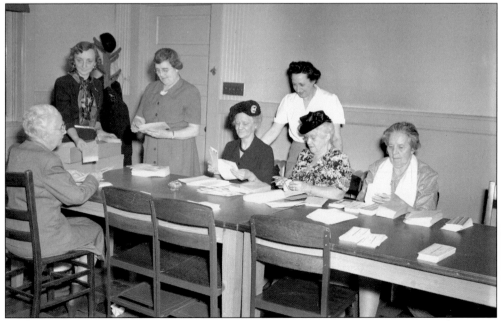

Mrs. H. B. Thompson, Mrs. Ves Chancellor, Mrs. I. J. Abraham, Mrs. W. H. Meadors, Susie Colcayzier, and two unidentified women, committeewomen of the Kentucky Society for Crippled Children, prepare Easter Seals for mailing in March 1949. (2004AV001 1.04-347.)

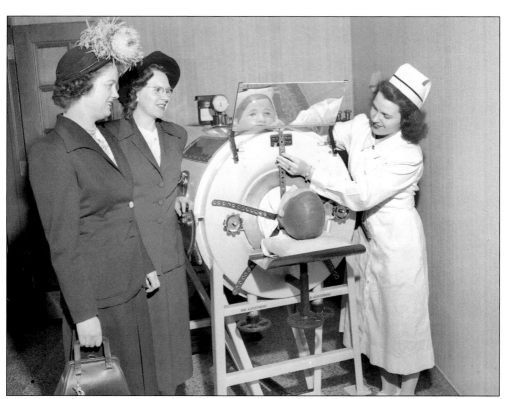

From left to right, Mrs. Leonard Powell, treasurer, and Mrs. James Dodson, president of the Iota chapter of Beta Sigma Phi, are with Martellia Hall, nurse in charge of St. Joseph Hospital isolation ward, as they inspected various equipment used in the treatment of polio victims. The chapter donated $75 to the March of Dimes in January 1950. (2004AV001 1.05-36.)

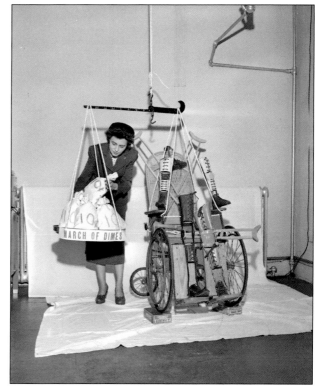

Mrs. Austin Moore, secretary at the March of Dimes headquarters, found that the nickels, dimes, and pennies that 13,000 school children contributed to the polio campaign outweighed a lot of the equipment they would buy with the funds. This picture was taken in January 1950. (2004AV001 1.05-104.)

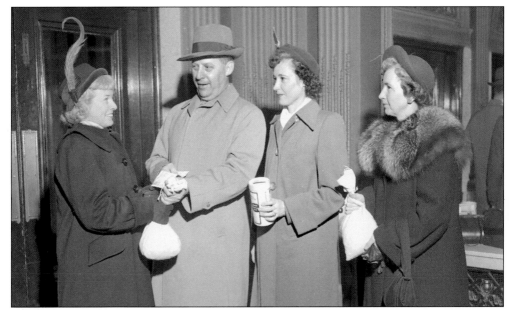

Fifty-four separate collections were made by members of the Pilot Club at various Lexington theaters, raising $2,183.20 for the March of Dimes in February 1950. Pictured from left to right are Mrs. E. S. Blackwell turning over the money to R. A. Sparks, general chairman of the polio drive, while Irene Coons, a member of the Pilot Club Board of Directors, and Nelia Cassity, captain in charge of collections at the Kentucky Theater, watch. (2004AV001 1.05-152.)

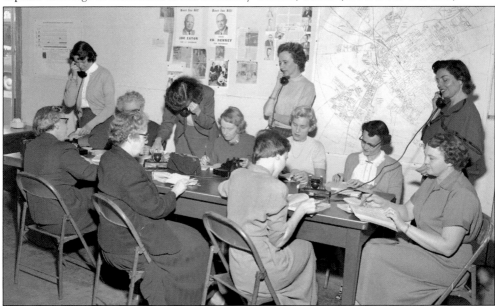

Republican women telephone invitations to GOP workers to attend a burgoo supper and rally at Tattersalls in October 1955. From left to right at the party's headquarters are (standing) Peggy Riggins, Katherine Frala, Mrs. Homer K. Forte, and Mrs. Rodes Clay; (seated, facing the camera) Mrs. D. R. Messick, Mrs. Thomas J. Carnes, Mrs. W. W. Greathouse III, Mrs. Joseph S. O'Neill, and Mrs. A. Wayne Johnson; (back to the camera) Mrs. Rondal Taylor, Rosa Daniels, and Mrs. Donald Weir. (2004AV001 K.2464.)

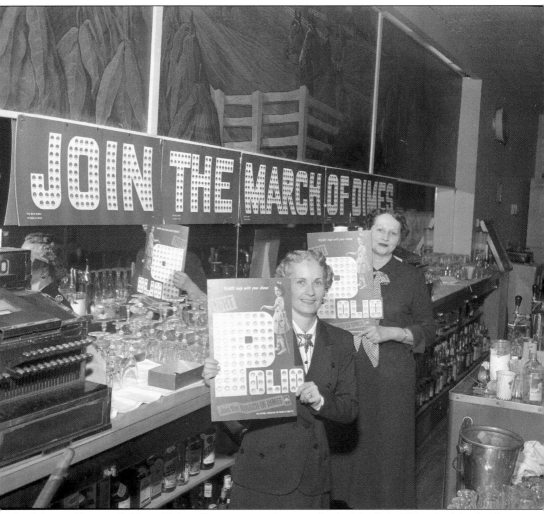

Mrs. Marvin Stoney (left) and Mary Spencer are photographed with their "Join the March of Dimes" banners. The women, employees of the Golden Horseshoe, served as chairwomen of the March of Dimes drive bar and grill detail in January 1955. The Horseshoe banner was the first one to be filled to capacity with 680 dimes. (2004AV001 K.105.)

These members of the Lexington Woman's Club present a kiln to the YMCA for its ceramic classes in November 1955. Pictured from left to right are Mrs. Robert Tice and Mrs. George Burrows of the Woman's Club fine arts department; Mrs. Earl Kauffman, student; Mrs. Calvin Waits, instructor; and Mrs. Bernard Johnson, co-chair of the club's fine arts department. (2004AV001 K.2652.)

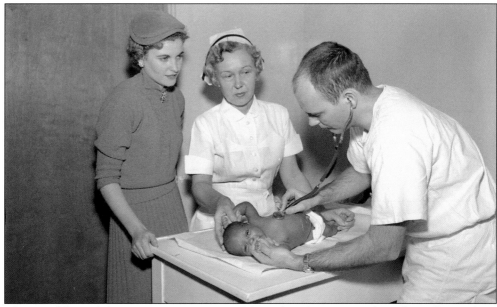

These members of the Lexington Woman's Club made a donation to the Baby Milk Supply in December 1955. Mrs. Robert W. Stopher (left), chairwoman of the American Home unit of the Lexington Woman's Club, toured facilities of the Baby Milk Supply. She is pictured with Ruby Royster, a Baby Milk Supply nurse, and Dr. Harold C. Haynes Jr., an intern at Good Samaritan Hospital. The visit was arranged after the unit presented Baby Milk Supply with a $60 check, the amount required for one year of care for a baby. (2004AV001 K.2741.)

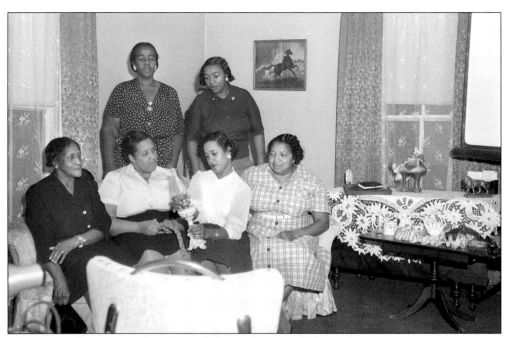

These Versailles Homemakers learned about Christmas lighting from Genevieve Covington, a Kentucky Utilities home economist, in December 1956. Pictured from left to right are (first row) Mayme Carter, Elizabeth Wilson, Genevieve Covington, and Elnora Beatty; (second row) Alice Jackson and Jennie Byrd. (2004AV001 M.3362.)

Mrs. Harold B. Pressman carries her puppy in a knapsack while collecting for the Mothers March on Polio in January 1957. The puppy was accepting donations for the "Give to Polio for Pete's Sake" fund in honor of Lexington's downtown dog, Smiley Pete, a stray who was taken care of by downtown Lexingtonians for many years. (2004AV001 N.268.)

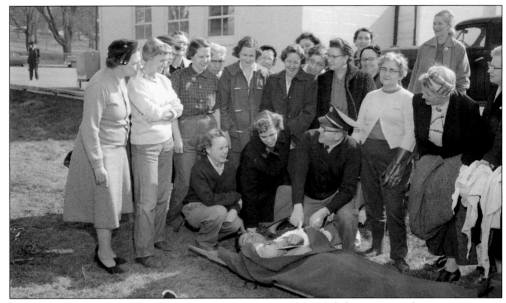

These Fayette County Homemakers were participants in civil defense rescue demonstrations in February 1957. Fireman Arnold Pena was the smiling victim of rescue demonstrations. He was "buried" and recovered from the basement of the Schott Street fire station by the two women kneeling. Pictured kneeling from left to right are Mrs. R. S. Larson, Lexington Filter Center volunteer; Mrs. P. C. Emrath, state director of women's activities, Civil Defense; and Capt. Dan Sallee, Lexington Fire Department drillmaster. The Fayette County Homemakers witnessed the rescue as part of a home protection course. (2004AV001 N.502.)

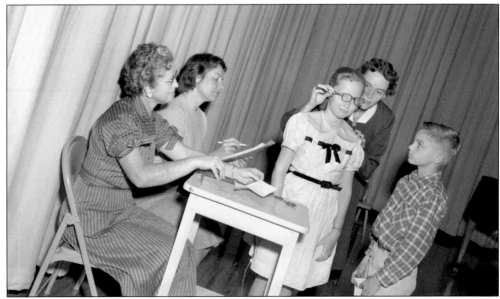

These school children receive eye tests sponsored by the Lexington Woman's Club in October 1957. Testing the sight of Glenda Hillman in the Woman's Club's new school visual screening program are, from left to right, Mrs. C. A. Boarman, PTA health committee representative; Mrs. W. Rodes Clay, woman's club president; and Mrs. Frank Hinton, nurse of the Lexington–Fayette County Health Department. (2004AV001 N.2687.)

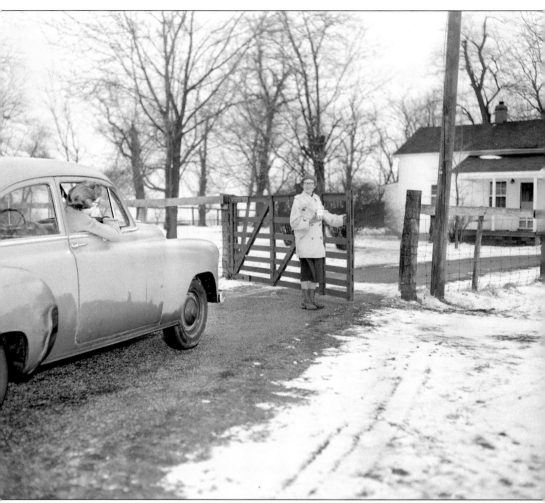

Mrs. Geary Simpson sits inside the car while her mother, Mrs. E. F. Ellis, takes part in the Marching Mothers campaign for polio in January 1958. Those with rural assignments worked long hours and contended with large gates and poor road conditions. Nonetheless women such as these devoted their time. (2004AV001 P.228.)

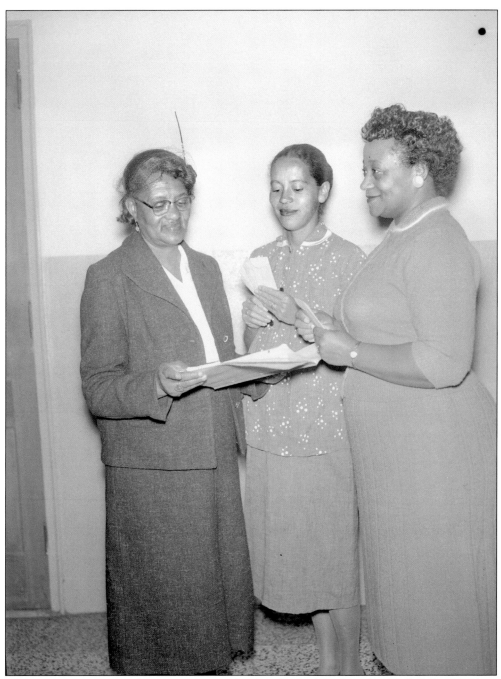

These women were top solicitors in the membership drive of the Douglass High School PTA in October 1958. Pictured from left to right are Lillie Mason, membership chairman; Mary Turley, 100 percent doorknocker; and Ollie Owens, 100 percent homeroom parent membership. The drive increased membership from 122 to 280. (2004AV001 P.2556.)

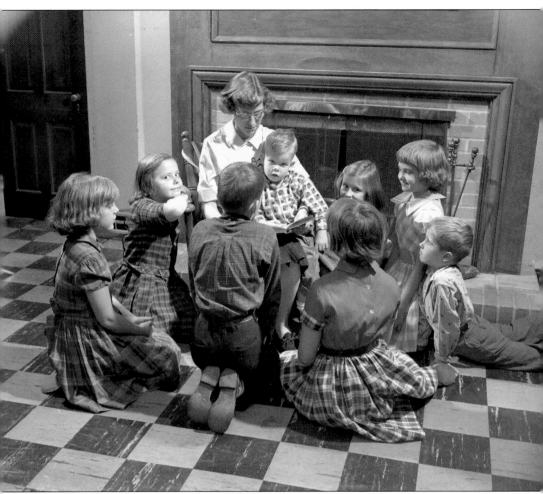

Mrs. Nathan Prewitt reads a story to a child at the Cisco Road Children's Home in January 1959. Mrs. Prewitt served as a house parent at the children's home. Her duties included "supervising and providing love and attention" for the children. The home was operated by the Fayette County Children's Bureau. (2004AV001 Q.84a.)

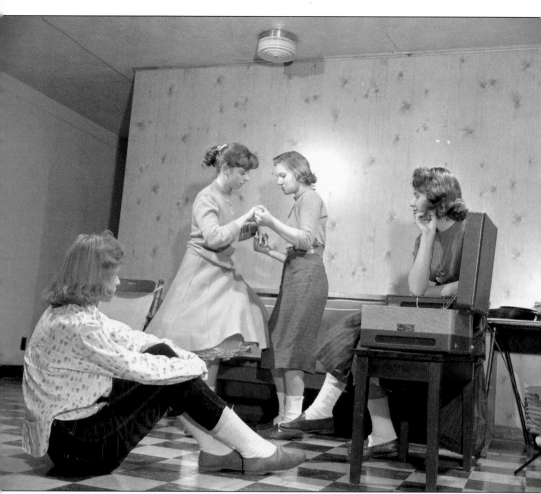
Teenage girls dance in the recreation room at the Cisco Road Children's Home in January 1959. (2004AV001 Q.84b.)

Seven

WOMEN'S RIGHTS

In 1919, when the suffrage victory was drawing near, the National American Suffrage Association was reconfigured into the League of Women Voters to ensure that women would continue to work after their victory. During the second wave of feminism in the 1960s, women continued to strive for equality. Women in Lexington encouraged others to vote, to fight for their beliefs, and to make strides in the workplace for all women. Title VII of the 1964 Civil Rights Act prohibited employment discrimination on the basis of sex as well as race, religion, and national origin. These images are only a small representation of the women's rights movement and what it became. It highlights early pioneers and local champions but does not begin to touch upon the movement through the late 1960s and 1970s.

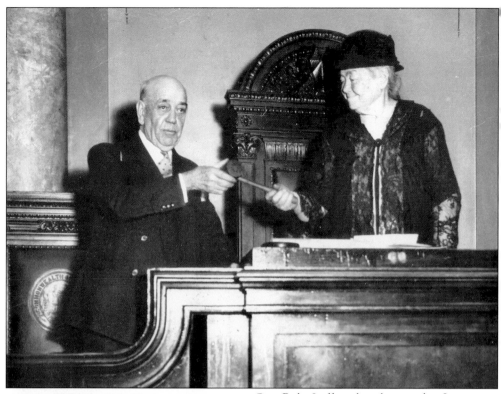

Gov. Ruby Laffoon hands a gavel to Laura Clay as temporary chairperson of the Kentucky convention to ratify the 21st amendment to the Constitution in November 1933. (PA64M4 4.)

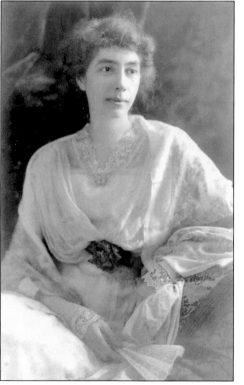

Madeline McDowell Breckinridge was a reformer and suffragist. She helped to establish a social settlement, was legislative chairman for the Federation of Women's Clubs, and served as vice president of the National American Woman Suffrage Association. Shortly before her death in 1920, Breckinridge was preparing for a meeting to convert the Kentucky Equal Rights Association into the League of Women Voters. This image was taken around 1910. (PA72M22 39.)

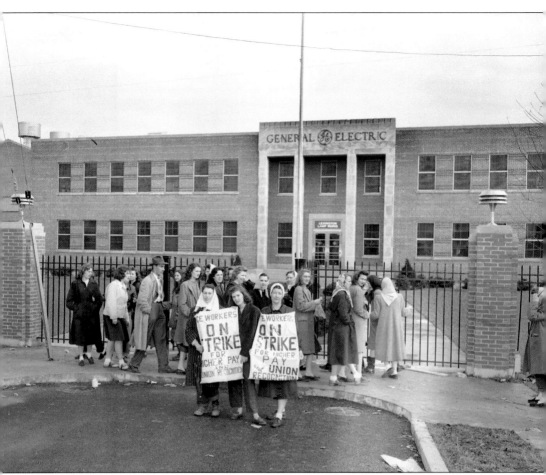

At a strike at the Rosemont Garden plant of General Electric, women hold picket signs protesting for higher pay and union recognition in March 1948. (2004AV001 1.03-273.03.)

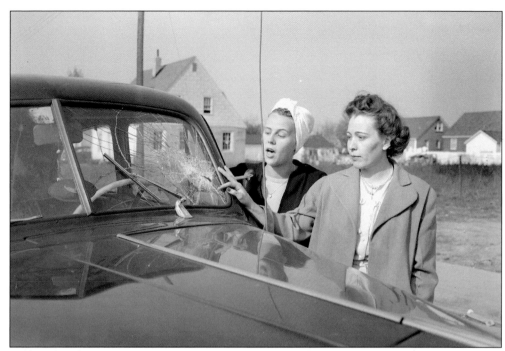

Jollene Barnes (left) and Geniveve Rhineheimer point at the smashed window of Geniveve's car in April 1948. Many workers reported damage to personal property during the General Electric strike. Jollene was previously arrested on a breach of peace charge after she lay down in front of a car attempting to enter the plant. (2004AV001 1.03-392.)

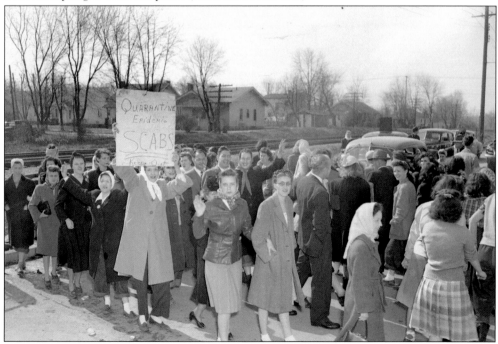

At a strike at the Rosemont Garden plant of General Electric, women hold picket signs warning scabs to "keep out" in March 1948. (2004AV001 1.03-277.08.)

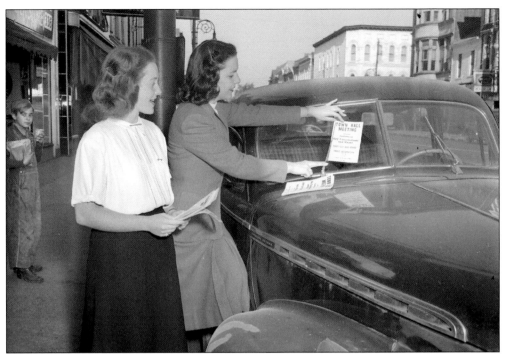

Charlotte Garr and Elizabeth Ann Bicknell kept themselves busy distributing handbills in downtown Lexington to announce the League of Women Voters' public town hall meeting for city candidates to answer prepared questions from the floor. This picture was taken in October 1947. (2004AV001 1.02-998.)

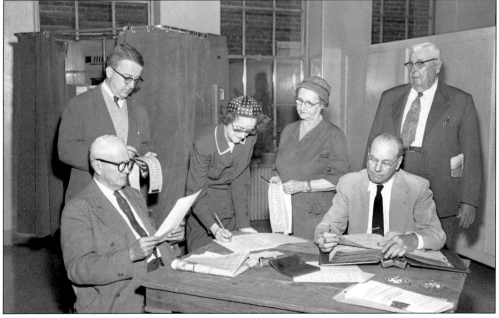

Phil Furlong was an early voter at the North Broadway precinct site at Christ Episcopal Church on North Upper Street in May 1958. From left to right are (seated) Joe Burris and Cal Cornish; (standing) Robert Rice, Miss Furlong, Ann R. Musser, and John Byrley. (2004AV001 N.1479.)

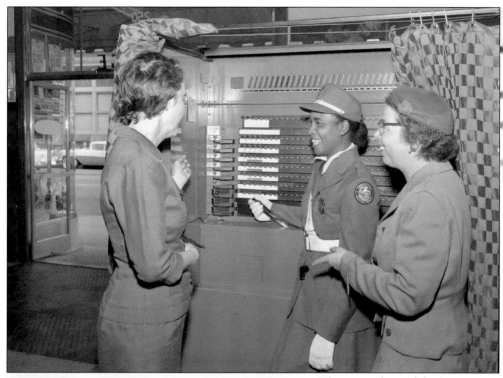

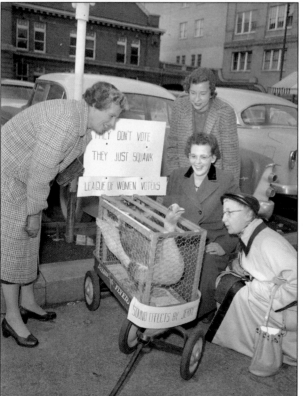

These members of the League of Women Voters demonstrate how to use the voting machine in November 1956. Pictured from left to right are Mrs. Rufus Lisle, Mrs. Lillian Mays, and Ann Green at the Kresge Company and A&P store as part of their pre-election services to the public. The group was also responsible for checking polling sites for irregularities on Election Day. (2004AV001 M.2865.)

From left to right, Mrs. Thornton Scott, Mrs. Thomas Stroup, Mrs. J. A. Duncan, and Mrs. Charles Thorne, members of the League of Women Voters, were urging everyone to vote with a goose wagon that read "Don't be a goose, go on and vote" in downtown Lexington. This picture was taken in November 1957. (2004AV001 N.2860.)

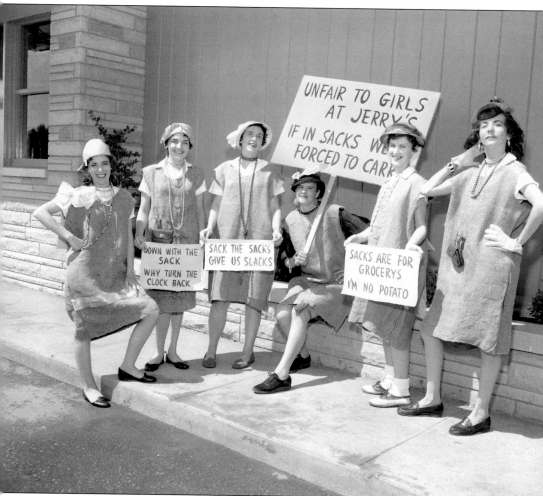

Waitresses at the Jerry's Drive-In Restaurant registered a friendly protest after hearing a report that the company was ordering new chemise uniforms for all its waitresses. The women reported for work dressed in uniforms made of burlap sacks. Pictured from left to right are Billie Columbia, Doris Jones, Melba Stevens, Florence Marshall, Sue Stafford, and Carol Lewis in May 1958. (2004AV001 P.1231.)

These Democrats turned out to hear Mrs. Joseph P. (Rose) Kennedy, mother of John Kennedy, and Mrs. Lyndon B. (Lady Bird) Johnson, wife of the vice presidential Democratic candidate, in a drive for women's votes in October 1960. (2004AV001 R.2426b.)

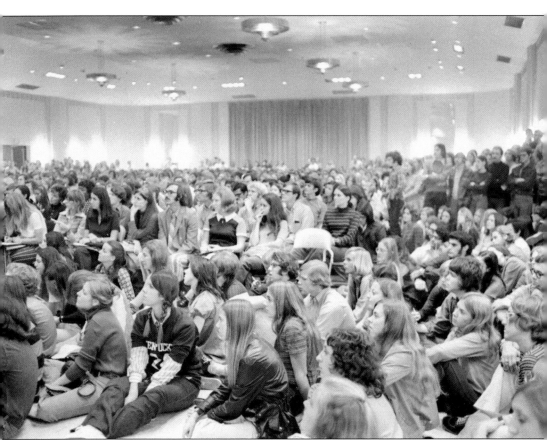

These men and women at the University of Kentucky Student Center Grand Ballroom gathered to hear prominent women's rights activists Gloria Steinem and Florynce Kennedy, who were discussing the women's liberation movement in September 1971. (2004AV001 CC.2051.)

DISCOVER THOUSANDS OF LOCAL HISTORY BOOKS
FEATURING MILLIONS OF VINTAGE IMAGES

Arcadia Publishing, the leading local history publisher in the United States, is committed to making history accessible and meaningful through publishing books that celebrate and preserve the heritage of America's people and places.

Find more books like this at
www.arcadiapublishing.com

Search for your hometown history, your old stomping grounds, and even your favorite sports team.

Consistent with our mission to preserve history on a local level, this book was printed in South Carolina on American-made paper and manufactured entirely in the United States. Products carrying the accredited Forest Stewardship Council (FSC) label are printed on 100 percent FSC-certified paper.

MADE IN THE USA